Grandma Moses

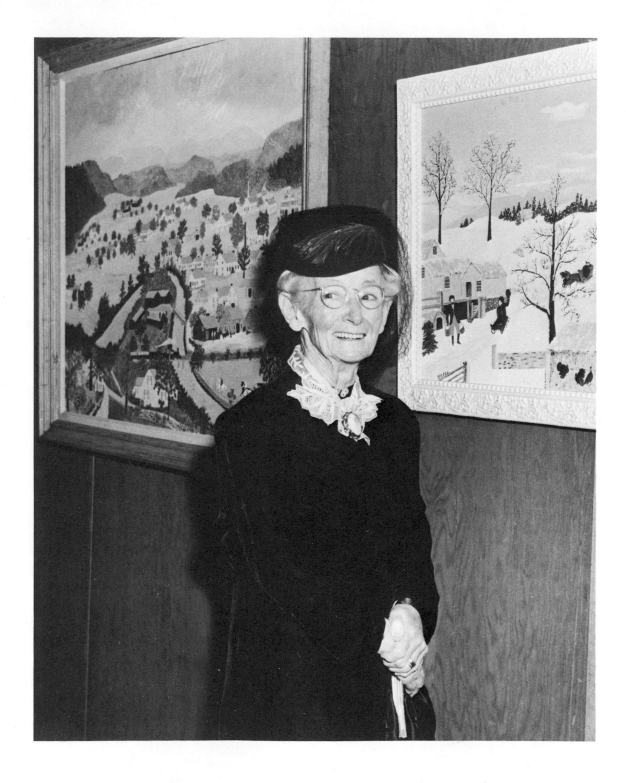

Grandma Moses

TOM BIRACREE

CHELSEA HOUSE PUBLISHERS

NEW YORK • PHILADELPHIA

On the cover Detail from *Sugaring Off* by Grandma Moses, 1955
Illustrations Copyright © 1989, Grandma Moses Properties Co., New York
Illustrations Copyright © 1952 (renewed 1980), 1973, 1982, Grandma Moses Properties Co., New York
Based on Grandma Moses: *My Life's History*, Otto Kallir: *Grandma Moses*, and Jane Kallir: *Grandma Moses: The Artist Behind the Myth*
Editorial Consultants: Hildegard Bachert and Jane Kallir, Galerie St. Etienne, New York

Chelsea House Publishers
EDITOR-IN-CHIEF Nancy Toff
EXECUTIVE EDITOR Remmel T. Nunn
MANAGING EDITOR Karyn Gullen Browne
COPY CHIEF Juliann Barbato
PICTURE EDITOR Adrian G. Allen
ART DIRECTOR Maria Epes
MANUFACTURING MANAGER Gerald Levine

American Women of Achievement
SENIOR EDITOR: Constance Jones

Staff for GRANDMA MOSES
TEXT EDITOR Marian W. Taylor
COPY EDITOR Lisa S. Fenev
DEPUTY COPY CHIEF Ellen Scordato
EDITORIAL ASSISTANT Heather Lewis
PICTURE RESEARCHER Lisa Kirchner
ASSISTANT ART DIRECTOR Loraine Machlin
DESIGNER Donna Sinisgalli
LAYOUT Design Oasis
PRODUCTION COORDINATOR Joseph Romano

Library of Congress Cataloging in Publication Data

Biracree, Tom, 1947–
Grandma Moses/Tom Biracree.
p. cm. —(American women of achievement)
Bibliography: p.
Includes index.
Summary: A biography of the American primitive painter who, at the age of seventy-six, without ever having had an art lesson, began painting realistic scenes of rural life which were critically acclaimed and made her famous.

ISBN 1-55546-670-2. —ISBN 0-7910-0446-5 (pbk.)
1. Moses, Grandma, 1860–1961—Juvenile
literature. 2. Painters—United States—Biography—Juvenile
literature. [1. Moses, Grandma, 1860–
1961. 2. Artists.] I. Title. II. Series.
ND237.M78B57 1989
759.13—dc19 88-34387
[B] CIP
[92] AC

CONTENTS

AMERICAN WOMEN OF ACHIEVEMENT

Abigail Adams
women's rights advocate

Jane Addams
social worker

Louisa May Alcott
author

Marian Anderson
singer

Susan B. Anthony
woman suffragist

Ethel Barrymore
actress

Clara Barton
*founder of the American
Red Cross*

Elizabeth Blackwell
physician

Nellie Bly
journalist

Margaret Bourke-White
photographer

Pearl Buck
author

Rachel Carson
biologist and author

Mary Cassatt
artist

Agnes De Mille
choreographer

Emily Dickinson
poet

Isadora Duncan
dancer

Amelia Earhart
aviator

Mary Baker Eddy
*founder of the Christian
Science church*

Betty Friedan
feminist

Althea Gibson
tennis champion

Emma Goldman
political activist

Helen Hayes
actress

Lillian Hellman
playwright

Katharine Hepburn
actress

Karen Horney
psychoanalyst

Anne Hutchinson
religious leader

Mahalia Jackson
gospel singer

Helen Keller
humanitarian

Jeane Kirkpatrick
diplomat

Emma Lazarus
poet

Clare Boothe Luce
author and diplomat

Barbara McClintock
biologist

Margaret Mead
anthropologist

Edna St. Vincent Millay
poet

Julia Morgan
architect

Grandma Moses
painter

Louise Nevelson
sculptor

Sandra Day O'Connor
Supreme Court justice

Georgia O'Keeffe
painter

Eleanor Roosevelt
diplomat and humanitarian

Wilma Rudolph
champion athlete

Florence Sabin
medical researcher

Beverly Sills
opera singer

Gertrude Stein
author

Gloria Steinem
feminist

Harriet Beecher Stowe
author and abolitionist

Mae West
entertainer

Edith Wharton
author

Phillis Wheatley
poet

Babe Didrikson Zaharias
champion athlete

CHELSEA HOUSE PUBLISHERS

"REMEMBER THE LADIES"

MATINA S. HORNER

Remember the Ladies." That is what Abigail Adams wrote to her husband, John, then a delegate to the Continental Congress, as the Founding Fathers met in Philadelphia to form a new nation in March of 1776. "Be more generous and favorable to them than your ancestors. Do not put such unlimited power in the hands of the Husbands. If particular care and attention is not paid to the Ladies," Abigail Adams warned, "we are determined to foment a Rebellion, and will not hold ourselves bound by any Laws in which we have no voice, or Representation."

The words of Abigail Adams, one of the earliest American advocates of women's rights, were prophetic. Because when we have not "remembered the ladies," they have, by their words and deeds, reminded us so forcefully of the omission that we cannot fail to remember them. For the history of American women is as interesting and varied as the history of our nation as a whole. American women have played an integral part in founding, settling, and building our country. Some we remember as remarkable women who—against great odds—achieved distinction in the public arena: Anne Hutchinson, who in the 17th century became a charismatic religious leader; Phillis Wheatley, an 18th-century black slave who became a poet; Susan B. Anthony, whose name is synonymous with the 19th-century women's rights movement and who led the struggle to enfranchise women; and, in our own century, Amelia Earhart, the first woman to cross the Atlantic Ocean by air.

These extraordinary women certainly merit our admiration, but other women, "common women," many of them all but forgotten, should also be recognized for their contributions to American thought and culture. Women have been community builders; they have founded schools and formed voluntary associations to help those in need; they have assumed the major responsibility for rearing children, passing on from one generation to the next the values that keep a culture alive. These and innumerable other contributions, once ignored, are now being recognized by scholars, students, and the public. It is exciting and gratifying to realize that a part of our history that was hardly acknowledged a few generations ago is now being studied and brought to light.

In recent decades, the field of women's history has grown from obscurity to a politically controversial splinter movement to academic respectability, in many cases mainstreamed into such traditional disciplines as history, economics, and psychology. Scholars of women, both female and male, have organized research centers at such prestigious institutions as Wellesley College, Stanford University, and the University of California. Other notable centers for women's studies are the Center for the American Woman and Politics at the Eagleton Institute of Politics at Rutgers University; the Henry A. Murray Research Center for the Study of Lives, at Radcliffe College; and the Women's Research and Education Institute, the research arm of the Congressional Caucus on Women's Issues. Other scholars and public figures have established archives and libraries, such as the Schlesinger Library on the History of Women in America, at Radcliffe College, and the Sophia Smith Collection, at Smith College, to collect and preserve the written and tangible legacies of women.

From the initial donation of the Women's Rights Collection in 1943, the Schlesinger Library grew to encompass vast collections documenting the manifold accomplishments of American women. Simultaneously, the women's movement in general and the academic discipline of women's studies in particular also began with a narrow definition and gradually expanded their mandate. Early causes such as woman suffrage and social reform, abolition and organized labor were joined by newer concerns such as the history of women in business and the professions and in politics and government; the study of the family; and social issues such as health policy and education.

Women, as historian Arthur M. Schlesinger, jr., once pointed out, "have constituted the most spectacular casualty of traditional history.

They have made up at least half the human race, but you could never tell that by looking at the books historians write." The new breed of historians is remedying that omission. They have written books about immigrant women and about working-class women who struggled for survival in cities and about black women who met the challenges of life in rural areas. They are telling the stories of women who, despite the barriers of tradition and economics, became lawyers and doctors and public figures.

The women's studies movement has also led scholars to question traditional interpretations of their respective disciplines. For example, the study of war has traditionally been an exercise in military and political analysis, an examination of strategies planned and executed by men. But scholars of women's history have pointed out that wars have also been periods of tremendous change and even opportunity for women, because the very absence of men on the home front enabled them to expand their educational, economic, and professional activities and to assume leadership in their homes.

The early scholars of women's history showed a unique brand of courage in choosing to investigate new subjects and take new approaches to old ones. Often, like their subjects, they endured criticism and even ostracism by their academic colleagues. But their efforts have unquestionably been worthwhile, because with the publication of each new study and book another piece of the historical patchwork is sewn into place, revealing an increasingly comprehensive picture of the role of women in our rich and varied history.

Such books on groups of women are essential, but books that focus on the lives of individuals are equally indispensable. Biographies can be inspirational, offering their readers the example of people with vision who have looked outside themselves for their goals and have often struggled against great obstacles to achieve them. Marian Anderson, for instance, had to overcome racial bigotry in order to perfect her art and perform as a concert singer. Isadora Duncan defied the rules of classical dance to find true artistic freedom. Jane Addams had to break down society's notions of the proper role for women in order to create new social institutions, notably the settlement house. All of these women had to come to terms both with themselves and with the world in which they lived. Only then could they move ahead as pioneers in their chosen callings.

Biography can inspire not only by adulation but also by realism. It helps us to see not only the qualities in others that we hope to emulate but also, perhaps, the weaknesses that made them "human." By helping us identify with the subject on a more personal level they help us to feel that we, too, can achieve such goals. We read about Eleanor Roosevelt, for example, who occupied a unique and seemingly enviable position as the wife of the president. Yet we can sympathize with her inner dilemma: an inherently shy woman who had to force herself to live a most public life in order to use her position to benefit others. We may not be able to imagine ourselves having the immense poetic talent of Emily Dickinson, but from her story we can understand the challenges faced by a creative woman who was expected to fulfill many family responsibilities. And though few of us will ever reach the level of athletic accomplishment displayed by Wilma Rudolph or Babe Zaharias, we can still appreciate their spirit, their overwhelming will to excel.

A biography is a multifaceted lens. It is first of all a magnification, the intimate examination of one particular life. But at the same time, it is a wide-angle lens, informing us about the world in which the subject lived. We come away from reading about one life knowing more about the social, political, and economic fabric of the time. It is for this reason, perhaps, that the great New England essayist Ralph Waldo Emerson wrote, in 1841, "There is properly no history: only biography." And it is also why biography, and particularly women's biography, will continue to fascinate writers and readers alike.

Grandma Moses

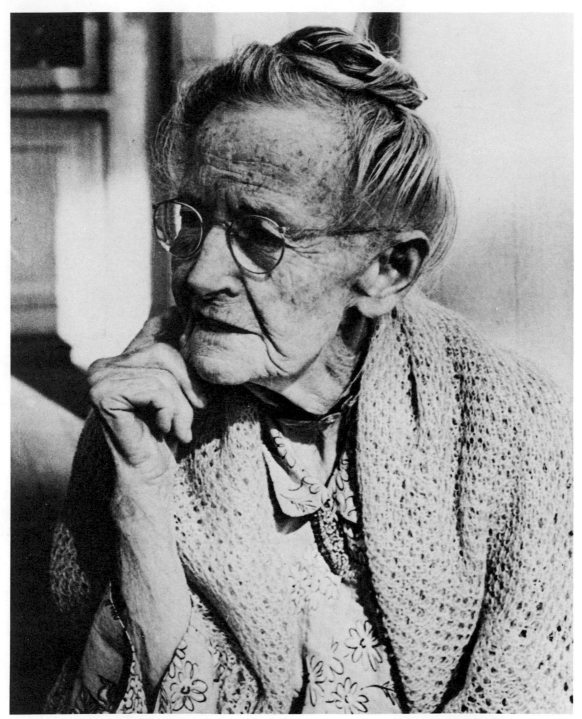

Anna Mary Robertson Moses, known as "Grandma" to her neighbors in Eagle Bridge, New York, became an international celebrity after her 80th birthday.

ONE

Happy Days

Heading home after a 1938 spring vacation in upper New York State, Manhattan-based engineer Louis Caldor was getting hungry. He spotted a drugstore in the tiny village of Hoosick Falls, about 30 miles north of Albany, and decided to stop. Inside the little store, he found the lunch counter he was seeking. He also made one of the most important discoveries in the history of 20th-century American art.

When Caldor approached the drugstore, he noticed a group of small, dusty paintings in the window. An enthusiastic amateur art collector, he was particularly interested in "primitive" paintings—works created by untrained artists who use simple, vivid images to depict the world around them. Caldor was stunned by what he saw in W. D. Thomas's drugstore that Easter Sunday in 1938. The four paintings in the window were vibrant, glowing re-creations of country life, painted in the folk art style he most admired.

The drugstore proprietor told Caldor that although he had displayed the modestly priced paintings (most of them cost about two dollars each) for a whole year, no one had shown much interest in them. The collector bought all the pictures. Then he learned, to his astonishment, that their creator was almost 80 years old. She was, said the proprietor, Mrs. Anna Mary Moses, a farm woman known to her family and friends as Grandma. She lived in the nearby village of Eagle Bridge.

In the days before television, many Americans used their evening hours to paint and embroider, creating objects to decorate their homes or give as gifts. They painted pictures, china plates, and tea canisters, and they stitched

designs on cloth to be framed or used as pillow cases or bedspreads. Much of this homemade art was crude but, occasionally, the works of a self-taught artist showed real inspiration.

Louis J. Caldor spent most of his weekends and vacations in search of such rare talents. Now that he had found one, he lost no time. Getting directions to the Moses farmhouse, he jumped into his car and sped to Eagle Bridge. The artist was out, but her daughter-in-law Mrs. Hugh Moses was

When Louis Caldor stopped for lunch in Hoosick Falls, New York, he discovered the remarkable paintings of Grandma Moses for sale in Thomas's Drugstore.

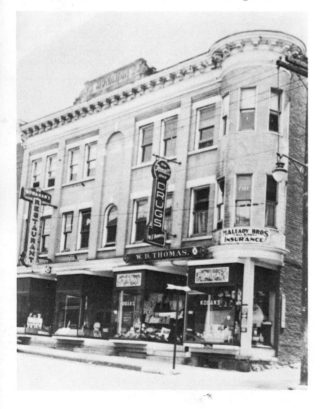

at home. After introducing himself, Caldor asked how many pictures Grandma Moses had painted. Dorothy Moses said there were probably 10 paintings in the house. Caldor announced that he wanted to buy every one of them, that he would spend the night in the area, and that he would be back the following morning. Dorothy Moses listened to Caldor's words, he later recalled, "pop-eyed with amazement, even disbelief."

When Grandma Moses got home, her excited daughter-in-law told her about their visitor. "Well, I didn't sleep much that night," the artist said later. "I tried to think where I had any paintings and what they were." After searching the house, she came up with only nine pictures. One was much larger than the others, and to bring the total to 10, she cut it in half and framed each section separately.

True to his word, Caldor returned the next day, bought the pictures, and took them back to New York City. He knew he had discovered a genius. It took patience and hard work to convince the rest of the world of that fact, but within only a few years of Caldor's chance stop in Hoosick Falls, Anna Mary Moses was an international celebrity. She had traveled a long road from her obscure beginnings more than three-quarters of a century earlier.

"I, Anna Mary Robertson, was born back in the green meadows and wild woods on a farm in Washington County, in the year of 1860, September 7th, of Scotch-Irish ancestry," wrote

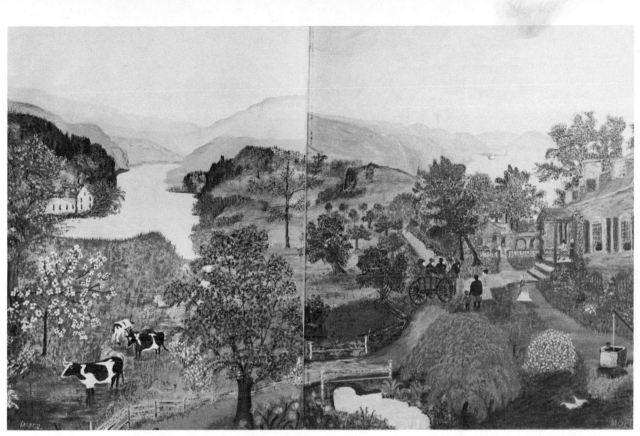

A line across The Shenandoah Valley *marks the place where Grandma Moses, needing an extra picture to complete her first customer's order, cut the painting in half.*

Grandma Moses in her 1949 autobiography, *My Life's History*.

The "green meadows and wild woods" of Moses' birth were situated about 120 miles north of New York City in upstate New York, near the border of Vermont. Lying in the foothills of Vermont's Green Mountains, Washington County is distinguished by beautiful and fertile valleys, carved by the ancient rivers flowing down the mountains.

Anna Mary Robertson was extremely proud that she had Native American blood. Writing about her forebears, she said, "There was one of them that married an Indian girl. . . . I have cousins here that show it very plainly. When once a man was boasting to me about his ancestors and that his folks came over in the *Mayflower*, I told him, 'You know, my folks were here to meet yours.' Then he didn't boast any more about the *Mayflower*."

When Anna Mary's great-grandfather, Hezekiah King, arrived in Washington County in 1775, he found an untamed wilderness. He cleared enough land for a farm, built a house, then marched off to fight the British in the American Revolution. After the war he returned and built a church; the

area was soon known as the King Church Valley. King's oldest daughter, Sarah, married William Archibald Robertson, whose father, a Scottish wagonmaker, had arrived in America about 1770. Russell King Robertson, the son born to Sarah and William in 1820, would one day have a daughter named Anna Mary.

Meanwhile, a pair of Irish immigrants—Gregory Shanahan and Bridget Devereaux—met and fell in love on a U.S.-bound ship in the mid-1830s. Married soon after they reached America, the couple settled in Washington County, where they eventually raised 11 children. Their firstborn, Margaret, was 16 years old when she met 35-year-old Russell King Robertson in 1856. Hardworking and ambitious, Robertson ran a farm near the land his grandfather had wrested from the wilderness, raised dairy cattle, and built and operated a water-powered flax mill. (Flax is a plant from which linen is made.)

Because few eligible young women lived in Washington County, and because Robertson spent so much time on his farm, he was still a bachelor at the age of 35. He asked Margaret Shanahan to marry him, and she accepted. The couple were soon the parents of two sons, Lester and Horace. Then, in

The rich farmland of upper New York State, seen here in an 1880 photograph, was a wilderness when Anna Mary Robertson's great-grandfather arrived in 1775.

17

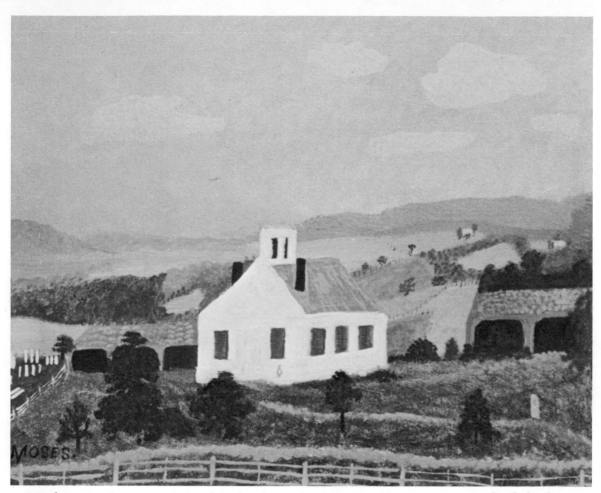

Washington County's King Church, shown here in a Moses painting, was built by her ancestor Hezekiah King soon after the American Revolution.

1860, their first daughter was born. Anna Mary was named for her mother's sisters, but everyone in the family called her Sissy. Until she was six years old, in fact, the little girl thought that *was* her name. "A man came into the yard one day and wanted to know what my name was," she later recalled of her sixth year. "I said my name was Sissy." When she told her mother of the man's question and her answer, she learned her real name for the first time.

Next in age to Anna Mary was Arthur, born a year after her; the two were inseparable companions during their early childhood. A few years after Arthur's birth, the Robertsons' second daughter, Celestia, arrived. Next came Miama, Ona, Joe, Sarah, and Fred, making a total of 10 children. ("We came in bunches, like radishes," Anna Mary remarked later.)

The Robertsons' farm and flax mill produced enough income to buy neces-

sities, but not enough for such luxuries as "boughten" toys and games. Television, radio, and movies were, of course, far in the future. Like most children of the time, the young Robertsons entertained themselves with homemade playthings, self-designed games, and explorations of the surrounding fields and farms. Anna Mary was particularly fond of outdoor activity. In her autobiography, she said her earliest memories were of "sporting with [her] brothers, making rafts to float over the mill pond, roaming the wild woods gathering flowers, and building air castles."

By the time each Robertson child reached the age of six, he or she was expected to assume a share of family responsibility. Because she was a girl, Anna Mary was assigned to work around the house and help take care of her younger siblings. "Many a time I had to rock the cradle," she wrote later. "I liked it, but I had rather been outdoors with my brothers. The four of us were always together. I always had to be one better than they. If Lester climbed the eaves of the house, I would go up to the peak. It was a strife with me to outdo them."

Margaret Shanahan Moses (below) was 16 years old when she married Russell King Robertson in 1856. Anna Mary was the third of the couple's 10 children.

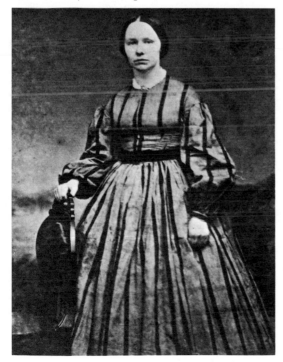

Russell Robertson (below, in an 1860 photograph) was 40 years old when his daughter Anna Mary was born. Like the rest of the family, he called her "Sissy."

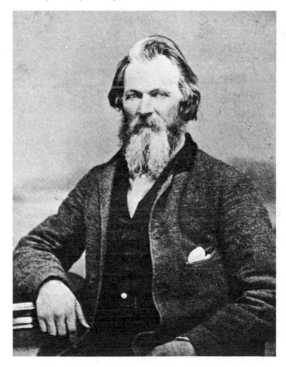

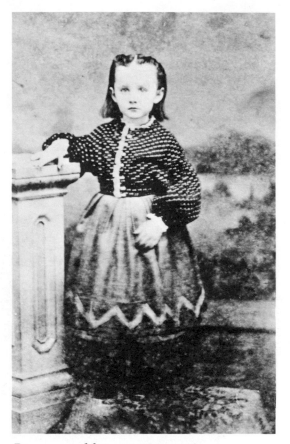

Four-year-old Anna Mary Robertson strikes a solemn pose in this 1864 portrait. Her memories from this age were of "gathering flowers and building air castles."

Among Anna Mary's chores were many that have long disappeared from modern American life. With milk from the family cows, she churned butter; she made jam from fresh berries, applesauce from the fruit of the family orchard, and syrup from the farm's maple trees. Every day, she and her mother brought potatoes and apples from the cellar to peel and cook, and every day they baked mountains of biscuits for the dinner table. One day of each week was set aside for clothes washing, another for mending and ironing. In the spring, the Robertsons used wood ashes and strained cooking grease to make their year's supply of soap. In the fall, they made beef-fat candles for the dark months ahead. During the long winter evenings, Margaret Robertson and her daughters sewed new clothes for the family by candlelight.

Although Anna Mary's chores varied with the seasons, each weekday was much like another. But then there was Sunday, the day the little girl looked forward to all week. As an adult, she wrote about going to church on Sunday: "What an enjoyment, here [neighbors] can exchange the news of the week, hear from the sick and the well, and spend the day in prayer, thanksgiving, and song, a day of pleasure and rest from drudgery."

After church, the Robertsons would spend the day together. In the spring and fall, they took long walks in the woods; on hot summer days, they swam in the pond by the flax mill; in the winter, they hitched up the horses and sailed through the countryside on a sleigh. But the Robertson children's favorite outdoor pastime was winter sledding. "Lester had a sleigh with cast-iron runners, Horace had an old wash bench upside down, but very safe, Arthur had a dustpan, and I an old scoop shovel," Anna Mary recalled. "Oh, what fun! We would play out for hours, and the thermometer at 25 below zero."

Moses' Lincoln, *painted in 1957, depicts a scene the artist had viewed 92 years earlier: houses draped in black cloth as mourning for the slain U.S. president.*

Life on the Robertson farm was self-contained, little affected by events outside the immediate neighborhood. Not even the Civil War, which ravaged much of the nation between 1861 and 1865, disturbed serene Washington County. Anna Mary was too young to remember much about the war, but she did vividly recall one somber day in 1865. On their way to visit her grandmother, she and her mother were driving their buggy through a nearby town when they noticed black cloth displayed in windows and doorways. Stopping at the town store to ask why, they learned that President Abraham Lincoln had been fatally shot the night before. "Oh, what will become of us now?" Anna Mary remembered her mother saying.

The artist also recalled that the Civil War had brought her Aunt Ruhama to Washington County. The widowed aunt and her three children lived in

Missouri, where she owned a mill and a grocery store. When Confederate troops burned her properties to the ground and threatened to force her 13-year-old son to join their regiment, Ruhama fled Missouri and brought her children to live in a house on the Robertson farm. "It was nice to have her and the cousins," Anna Mary said.

In later years, Anna Mary Robertson referred to her youth as "my happy days, free from care and worry." Well-remembered events from her childhood included a visit from a traveling salesman who gave her a piece of ribbon for her doll, the purchase of her first "boughten" dress, and her father's arrival with a box of firecrackers one Fourth of July. Today's young people might find little excitement in such incidents, but for an upstate farm girl of the 1860s, they were red-letter occasions. Their details were etched into her memory.

Young Anna Mary loved to make paper dolls, dressing them in scraps of paper she colored with grape or blackberry juice. Her father sometimes returned from his trips to town with a special present for the children: sheets of blank newsprint. To make each thin sheet last as long as possible, Anna Mary covered every square inch of both sides with pencil and chalk drawings.

"My oldest brother loved to draw steam engines," she wrote later. "The next brother went in for animals, but as for myself, I had to have pictures and the gayer the better." By "pictures," she meant scenes that included houses, barns, trees, and people. To the amuse-ment of her brothers, the little girl called these scenes her "lamb scapes."

The little girl's relatives encouraged her artistic activities. As an occupation for long winter evenings, creating artwork was considered both wholesome and useful. A farmhouse of the period might have a few calendar pictures or religious prints on its walls, but most of its decorations were made by the family who lived there. Both men and women worked on embroidery, paintings, and murals to adorn the walls. Farm women made tablecloths, fancy pillows, lace trimmings for furniture, and elaborate quilts and bedspreads. When a family wanted a decorative vase, platter, or other piece of pottery, members made it themselves, shaping clay, hardening it in the oven, and painting it. Anna Mary's artistic skills, therefore, were seen as valuable.

Education was seen as less valuable. When she grew up, Anna Mary would recall the local attitude about schooling, especially for girls. She noted that popular opinion had not advanced much since her mother's day, when, "If a woman could write her own name, that was all that was necessary." Upstate New York schools of the time were open for two sessions each year: three months between the fall harvest and the spring planting and three months between planting and the next harvest. "Little girls did not go to school much in winter, owing to the cold, and not warm enough clothing," Anna Mary wrote later. "Therefore my school days were limited."

Anna Mary attended a total of six

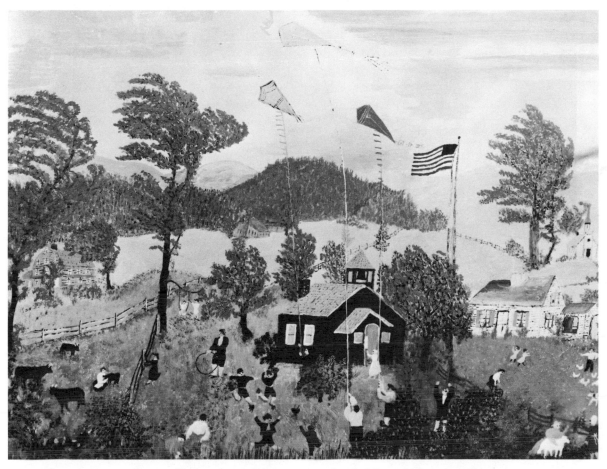

In Flying Kites, *a typically exuberant Moses work, children frolic outside a one-room schoolhouse much like the one attended by the painter herself.*

summer sessions, beginning at the age of seven. She never completely mastered spelling, but reading came easily, and she loved geography. Fascinated with the maps in her schoolbooks and on the classroom walls, she spent hours copying them from her schoolbooks. Hers were so well drawn that her teachers often saved them from one year to the next, using them to instruct other children.

When Anna Mary reached her 12th birthday, she was ready to leave home, find employment, and start practicing the skills she would one day need to run a farm household of her own. As her mother had done before her, she took a job as a "hired girl"—an employee whose household position fell between that of a family member and a maid. As she later put it, "Then began the hard years."

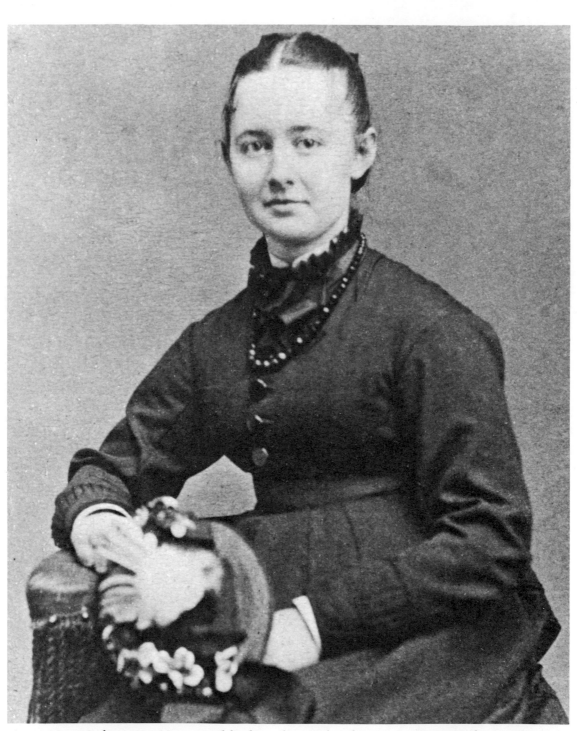

Anna Mary Robertson, 15 years old when she sat for this portrait, was only 12 when she went to work as a "hired girl." The job, she said later, was "a grand education."

T W O

Taking "the Bitter with the Sweet"

Anna Mary was the second Robertson child to leave home. She was preceded by her older brother Lester, who had found a job as a "hired man" a year earlier. Their father had taken Lester's departure as a matter of course, but when Anna Mary announced that she planned to go to work, Russell Robertson objected. Unlike most of his neighbors, he believed in the value of a good education—even for women—and he urged his daughter to stay at home and continue her schooling. But Anna Mary had her own convictions. She knew the family would benefit by her income, and she had been taught that the welfare of the whole group was more important than that of its individual members. If other 12-year-old girls eased the burden at home by supporting themselves, then she would, too.

Although she called the next period in her life "the hard years," Anna Mary considered herself lucky to be employed by Thomas Whiteside, a well-to-do farmer, and his invalid wife. The Whitesides, who had no children of their own, quickly grew fond of their new hired girl. "They called me 'child,'" she recalled. Mrs. Whiteside "didn't want anyone to come near her but me—'child' had to do everything. She was an awfully nice woman. I suppose I had got so she would see me as her own child. I felt the same way."

Anna Mary worked hard for her keep. She was responsible for an assortment of chores, including all the cooking, cleaning, sewing, butter churning, and gardening. Still, the three years she spent with the Whitesides were filled with exciting experiences. With many

children and little money, her own family had been able to afford no luxuries; their simple farmhouse contained plain, useful furniture and implements, all of them either made at home or bought as cheaply as possible. The Whitesides, on the other hand, had no children and plenty of money; their home was filled with objects selected for their beauty.

It may have been at the Whitesides' that Anna Mary saw Currier and Ives prints for the first time. Nathaniel Currier and James Merritt Ives were pioneers in lithography, a process that involves drawing a picture with oil on a specially prepared stone, inking the stone, then printing the image on paper and hand coloring it. Hugely popular in the late 19th and early 20th centuries, Currier and Ives prints—which often depict such activities as corn husking and maple sugaring—decorated the parlor walls of countless American homes.

Moses painted The Whiteside Church *and its "old burying ground" in 1945. As a teenager, she worshiped here with the Whiteside family, her first employers.*

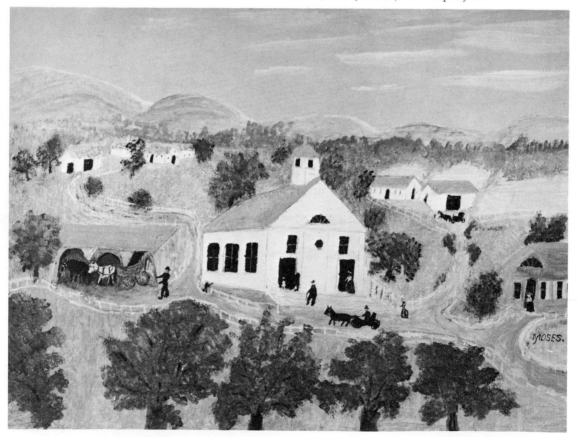

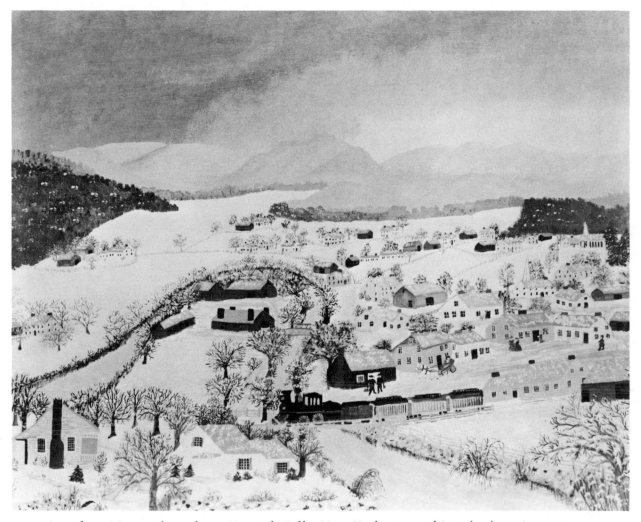

Grandma Moses often chose Hoosick Falls, New York, as a subject for her pictures. Painted in 1944, this version shows a steam-powered train entering the village.

In later life, Anna Mary would sometimes find inspiration in these pictures and their familiar rural themes.

Mrs. Whiteside often busied herself with "fancywork," ornamental, hand-stitched pictures and scriptural quotations. Eager to teach her young hired girl about both needlework and religion, Mrs. Whiteside promised her a silver thimble if she read the Bible from cover to cover. "I read the Bible all through, but didn't know much more about it than when I started," confessed Anna Mary afterward. Nevertheless, she got the silver thimble, long her most treasured possession. "I was very

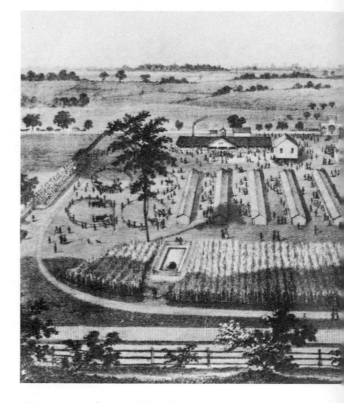

Visitors flock to exhibition stalls at a 19th-century New York State agricultural fair. For young Anna Mary Robertson, such expositions were the high point of each year.

proud of it," she said later, "and always wore it, till it wore holes all through it."

Much to Anna Mary's sorrow, Mrs. Whiteside died three years after hiring her. Her husband asked the young woman to stay on, and she agreed to spend another year keeping house and cooking for him. "He was a man in his 70s. I was just like a kid to him," she recalled. But she was pleased when Whiteside's visitors praised her hearty meals, which often featured such specialties as hot biscuits, homemade butter and honey, and home-cured dried beef. "I sometimes now think," she wrote later, that "they came for eats more than to see him."

Soon after she left the Whiteside household, Anna Mary paid a call on her family, who had moved to another village. She arrived to find her mother and seven of her brothers and sisters ill with measles, a very serious disease in the days before modern medicine. She helped her father nurse the rest of the family until she, too, became ill. She recovered easily, but the aftereffects of the epidemic took their toll on her siblings. Within a few years, Miama, Horace, and Arthur—Anna Mary's favorite brother—were dead, all of them under 21 years old. "We had to take the bitter with the sweet always," Anna

Mary noted. Looking back on this sad period, she wrote, "Mother was very matter-of-fact, and she said, 'As you are born you must die,' and father took it in that way too."

At the age of 16, Anna Mary could not feel quite as philosophical as her parents did; she was hit hard by the deaths of her beloved employer, her sister, and her brothers. But she refused to dwell on the tragedies, concentrating instead on what lay ahead. "In the springtime of life," she observed, "there is plenty to do." Over the next 10 years, she took a series of hired-girl jobs, working hard but enjoying her infrequent vacations all the more. "I would look forward from one fall to

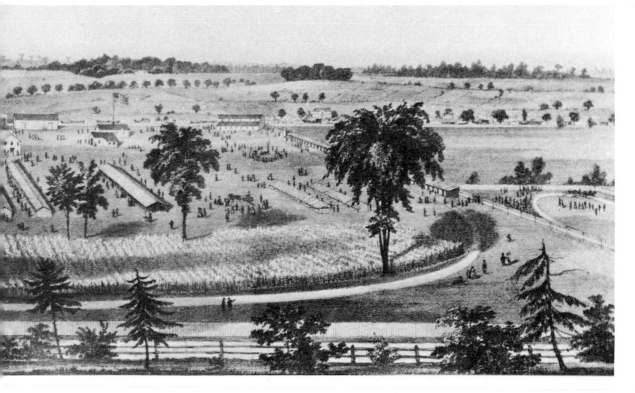

another just to go to the fair," she recalled.

She attended the New York State Fair, her first, in 1876. With a group of friends, she took a train ride—also her first—to Troy, New York, where the large agricultural exhibit was held. Although she reported being extremely "car-sick" on the smoky, jolting train, she loved the fair. She reveled in the flower display ("Oh, was not that grand!" she wrote); the poultry and bird show ("The first time I had ever seen a parrot"); the array of up-to-the-minute "cast iron cooking stoves of every description"; the pies and hot gingerbread ("Oh, those were the days—no hot dogs or sandwiches, that one never knows what the contents is!"); and the music hall ("There you could not hear yourself think, but it was grand").

As the years passed, most of Anna Mary Robertson's friends married and started families. Relatives told her it was time for her, too, to settle down, but she had no intention of marrying merely for the sake of marrying. She continued to work as a hired "girl" until she was in her late twenties. In 1886 she took a job in the home of Sylvester James, his wife, and their three small children. Soon after Anna Mary arrived at the Jameses', one of the children took her hand and led her to the kitchen. "There," she wrote later, "stood a tall, blue-eyed man."

The stranger, she said, "proved to be a Thomas Salmon Moses, Sylvester James's hired man, and I was the hired girl. So under the circumstances, we gradually became acquainted." As the two got to know each other better, each formed a high opinion of the other. "He found me a good cook," recalled Anna Mary, "and I found him . . . very temperate and thrifty. In those days we

Still single at 18, Anna Mary Robertson was considered an "old maid" by some of her friends. The young woman, however, had no desire to rush into marriage.

didn't look for a man with money, but for a good family, good reputation. . . . Some women like a man because he is rich, but that kind of 'like' is not lasting, just lasts as long as the pocketbook."

Anna Mary Robertson's "kind of like" grew stronger as the months passed. Thomas Moses, she said later, "was a wonderful man, much better than I am, he was a Christian, always trying to do good to his fellow man." Moses' thoughts about Robertson were apparently running in the same direction. One year after he met her, he asked her to marry him, and she accepted. He told her he had always wanted to live in the South, where the climate was mild and where the price of a farm was much lower than in New York State. They could start out, he said, in North Carolina, where he had been offered a job managing a horse ranch. Robertson liked the idea, and the couple agreed to head south after their wedding.

Anna Mary Robertson was full of high hopes: As she put it in her autobiography, "Those that know nothing fear nothing." After harvesting Sylvester James's crops, Moses accompanied his future bride to her parents' home. The Robertsons were sad to see their daughter leave for a distant state, but they approved of her choice. "Father liked Thomas very much; he was all right, couldn't have been better in his way of thinking," recalled Russell Robertson's daughter.

Anna Mary Robertson and Thomas Salmon Moses were married in Hoo-

Attired in a formal black suit, Thomas Salmon Moses sits for his wedding portrait in 1887. He was, said his bride, "a wonderful man, much better than I am."

sick Falls, Thomas Moses' hometown, on November 9, 1887. The groom wore a somber black suit; the bride was attired in a dark green dress with a stiff, high collar; black stockings; high-buttoned shoes; and a hat topped by a bright pink feather. In her autobiography, she revealed what a well-dressed woman of the day wore under such a costume: "The first thing I had on was a chemise, then my corsets, a corset waist, a pair of pantsies, a little flannel skirt, a bustle, a white skirt. . . . The dress cloth went over that, a long skirt reaching to the floor. Then an overskirt over that, that reached the floor and was tucked up on the sides." The day was chilly, but, noted Moses dryly, "I didn't need a coat with all the skirts I had on."

When the couple went to the railroad station after the wedding, they found a crowd of friends and neighbors waiting to see them off. Laughing and cheering, the townspeople jokingly scolded Thomas Moses for "taking away the best girl in the country." The day was clear and bright, and Anna Mary Moses knew she had picked the right man. "I believed," she recalled later, "that we were a team and [that] I had to do as much as my husband did." The young woman, who had spent the first 27 years of her life within 12 miles of her birthplace, was ready to leave her familiar world for a new life.

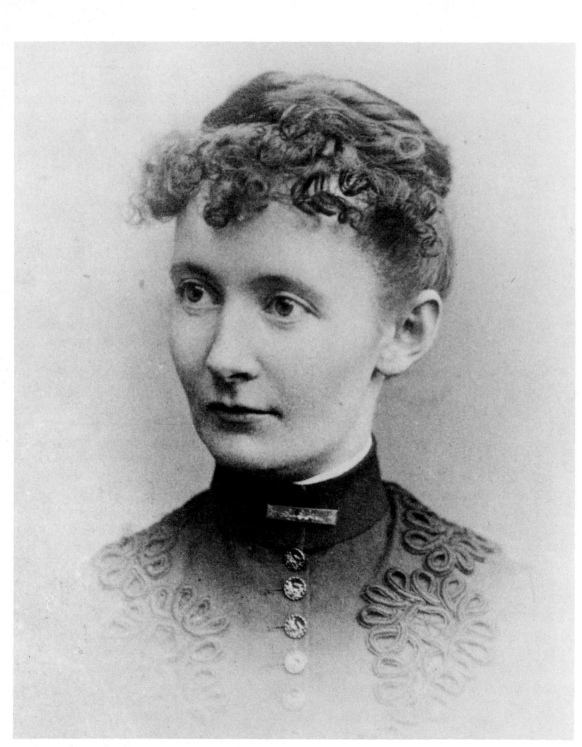

Anna Mary Robertson Moses was 27 years old when she and her husband left New York State. That year, 1887, they headed for a new life in the South.

THREE

The Married Years

After November 9, 1887, Anna Mary Robertson's life would change abruptly. A rural hired girl one day, she was a married woman the next, speeding away from the only world she had ever known.

In 1887, a trip from upstate New York to North Carolina was a major expedition. Anna Mary and Thomas Moses left Hoosick Falls, spent a night in Albany, then took a train to New York City, a ferry to New Jersey, another train to Washington, D.C., and yet another to Staunton, in Virginia's Shenandoah Valley. The new Mrs. Moses was delighted by the Virginia countryside. "It was beautiful," she remembered. "We left the ground all frozen up North, and the flowers were in bloom down there." Also in evidence, however, were scars remaining from the Civil War, ended more than 20 years earlier but never forgotten in the South. Observing the foundations of houses and barns burned by Union troops, the young northerners must have wondered if they would be resented by the people of this still-wounded land.

The travel-weary couple decided to spend the night in Staunton before continuing their journey south. When the landlady of a local boardinghouse answered their knock, Thomas Moses cleared his throat and blurted out, "I am a Mr. Moses from New York State and this is my wife and we would like to get board for over Sunday." Anna Mary was thrilled. "It was the first time," she said later, "that I heard him call me his wife."

The Moseses need not have worried about their reception: Mrs. Bell, the owner of the boardinghouse, opened

In her 1959 painting, Eagle Bridge Hotel, *Moses included a train similar to the one that she and her new husband had taken 82 years earlier.*

the door wide and said, "Come in and welcome." This "nice old Southerner," as Anna Mary Moses called her, invited the couple into her parlor and introduced them to the other boarders. When Thomas Moses remarked that he was out of shaving soap, Mrs. Bell directed him to a nearby drugstore, where he fell into a conversation with the proprietor.

As they chatted far into the night, Moses told the druggist about his plan to settle in North Carolina. But the Shenandoah Valley, said the druggist, was "the paradise of the world"; Moses and his wife would be foolish to go any farther south. Then the druggist told him about a 100-acre farm outside of town that was available for rent. Moses agreed to look at it the next day.

What he saw was a rundown but fertile farm; set in a broad valley, the place included a furnished house, a barn, and farm equipment. The beauty of the Virginia countryside and the friendliness of its inhabitants convinced the Moseses to change their plans. Agreeing to rent the little farm, they bought the previous occupants' household supplies and livestock, "even to their chickens and cat," recalled Anna Mary. "So within 30 days from our marriage," she added, "we were in a strange land in our own home. Now we were in the swim—it was paddle or sink!"

Making a living from a neglected farm was hard work, but hard work was nothing new to the Moseses. Anna Mary planted a garden, canned fruit

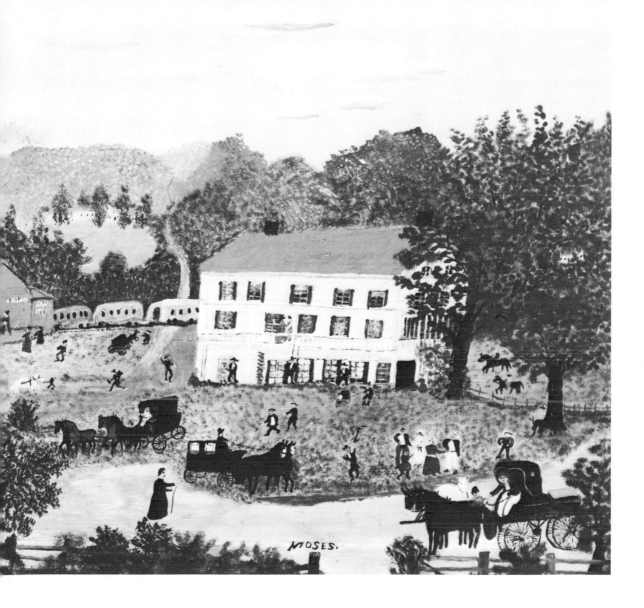

and vegetables, made bread, and raised chicks from the 12 old hens she and Thomas had acquired with the farm. By the following spring, she had 118 young birds. (Chickens, she said, were "lots of care but good company.") Applying another skill she had learned as a young girl, she began to churn butter from the

milk of the two cows they had bought.

Churning three times a day was tiring, but Anna Mary enjoyed it. "I could look off down the valley many miles; when trains came through, it was beautiful to watch the smoke rolling out against the Blue Ridge Mountains," she wrote later. "How I wished that I could paint a picture of it, the white and gray against the blue!" But Anna Mary Moses was too busy to think much about painting; she planned to help support herself and her husband by selling butter. When she told neighbors about her scheme, however, they just smiled. "You could buy all the butter you could carry for eight cents a pound," they told her.

Moses knew her product was superior to anything in the area, and she asked her husband to bring a batch to the local store. The grocer was skeptical about the "Yankee butter"—until he tasted it. Then he offered to pay 12 cents a pound for all the butter Moses could make. As the weeks passed, he raised the price, first to 15 cents, then to 20 cents. A few months later, Anna Mary recalled with satisfaction, "I had sold enough butter to pay for our two cows."

The fame of the Moses butter grew steadily. In the summer of 1888, a local businessman invited the couple to take over a 600-acre farm he owned in a nearby town, guaranteeing them 50 cents a pound for all the butter they produced. At first, the Moseses were hesitant about taking on such a big job, but then Thomas's sister Mattie wrote to say that she and her husband wanted to move south.

The two couples agreed to move to the new farm together, sharing the big house and the labor. There was no shortage of the latter. The men tended the crops and the livestock, and the women had their own jobs. "Soon the milk commenced to come to the house," Anna Mary Moses recalled, "and that was my work to take care of. Mattie took care of the cooking. So we were doing fine."

Anna Mary Moses especially needed help because she was pregnant with her first child. On December 2, 1888, "the nicest and prettiest baby," Winona Robertson Moses, was born. Within a few days, Moses was back at work, churning 160 pounds of butter each day. "Those were busy days; sometimes we would have to churn and print up [stamp with the Moses name] the butter at night; always [got] up at one o'clock to gather the vegetables and load up the truck wagon so as to leave at four o'clock in the morning to be in Staunton by seven o'clock," Moses recalled later. The work, she added, "paid off as far as money is concerned."

The Moseses' days were filled with practical matters, but there were moments of poetry, too. Thomas, who knew his wife loved flowers, sometimes used them to demonstrate his affection for her. In her autobiography, she described such an occasion: "Once Thomas went off by the tenant house, and saw this dogwood tree all in bloom.

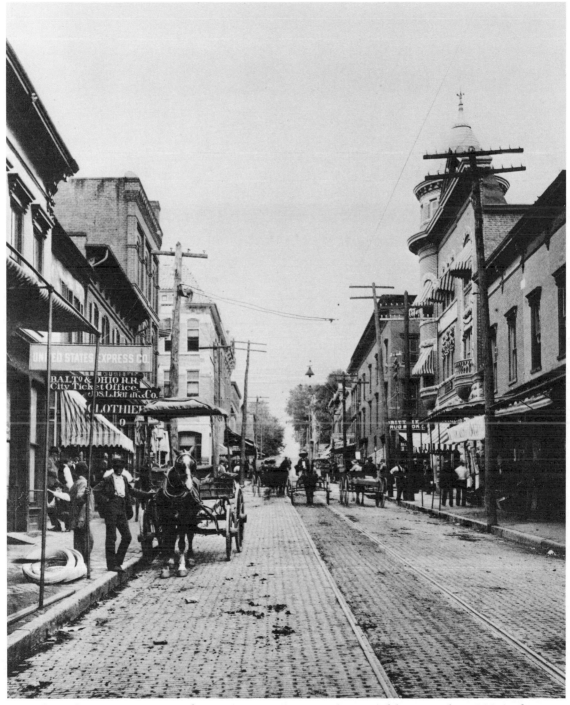

When the Moseses arrived in Staunton, Virginia (pictured here in the 1880s), they intended to spend only one night. Their stay in the area, however, lasted 18 years.

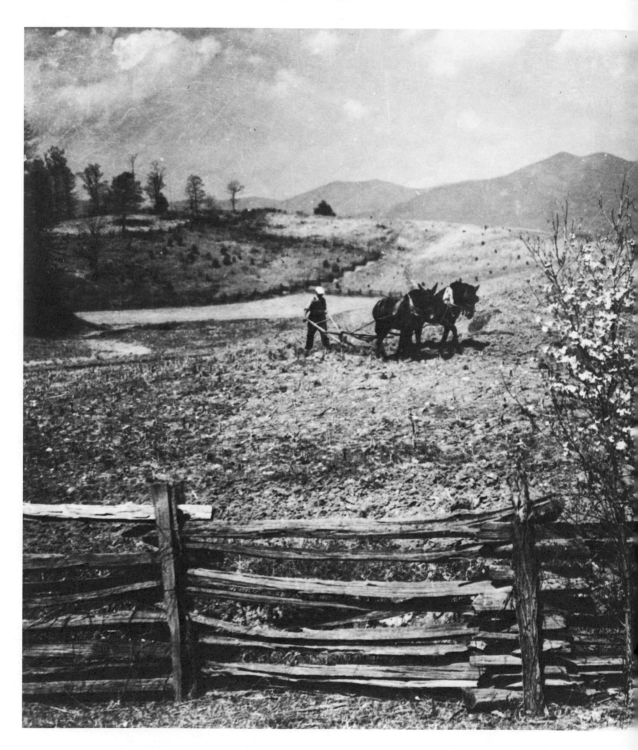

He brought in a branch, it was like half a tree. . . . He put it in the jar of water by one side of the room, and put up a couple of nails to the branches to hold them up; it reached clear to the ceiling. It was gorgeous; you could hardly believe it, I had never seen anything like that, have never seen it since, either."

On December 2, 1891—exactly three years after Winona (who was always called Ona) was born—Anna Mary Moses gave birth to a son, Loyd. At first Ona was jealous ("She didn't see why he had to be there at all," observed her mother), but the little girl soon grew fond of her new brother. Over the next decade, Anna Mary Moses would give birth to eight more babies, three of whom—Forrest, Anna, and Hugh—would live, like Ona and Loyd, to adulthood. Of the other five, Moses noted sadly in her autobiography, "one lived to be six weeks, and the others were dead born, stillborn, they called it. I left five little graves in that beautiful Shenandoah Valley."

The Moses family soon went into the milk business. Thomas took care of the cows and delivered the milk; his wife strained and bottled the hundreds of quarts their herd produced each day. Mattie and her husband worked alongside the Moseses, and as Anna Mary's youngsters grew older, they assumed

A farmer begins his spring plowing in the Shenandoah Valley, a region that charmed Anna Mary Moses. There, she said, "We had all the wants of life and good neighbors."

39

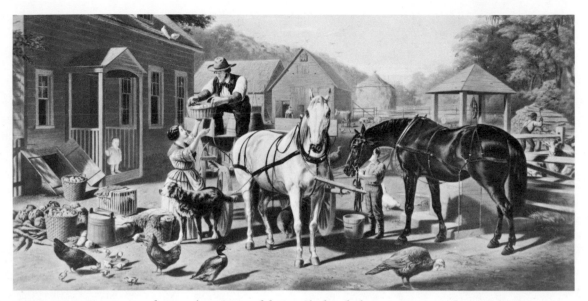

Preparing to go to market, a farmer and his wife load their wagon with fresh produce. The Moseses performed this chore at four o'clock every morning.

their own responsibilities. "I didn't bring up the children," Moses wrote later, "they kind of come up. They were always with me in the house helping, till they started into school."

In 1896, Anna Mary and Thomas Moses finally bought their own farm, a place called "Mount Airy." Mattie and her husband, meanwhile, decided to return to New York State. The Moseses farmed Mount Airy for seven years, then sold it in 1903 and bought a "beautiful place" on a riverbank near Staunton. Here, life became easier for the hardworking couple, who had carefully saved most of their money over the years. The new farm, Anna Mary noted, "had a large vineyard on it, but there was not much farm work, only 20 acres. We kept our two cows, so we lived good."

Now that her children were all in school, Moses decided to go into business for herself, making and selling potato chips. She started out by offering a nearby grocer a pound of chips in exchange for 25 cents' worth of groceries. Like her "Yankee butter," her crisp, homemade potato chips proved immensely popular. Soon she was making them by the barrel and even shipping them to customers in other cities. "Well, that was the potato chip business," she recalled with pride. "Always wanted to be independent; I couldn't bear the thought of sitting down and Thomas handing out the money—just like climbing the house in my childhood days, I wanted to be the big toad."

Anna Mary Moses had grown to love the Shenandoah Valley, where the climate was agreeable, the soil fertile, and

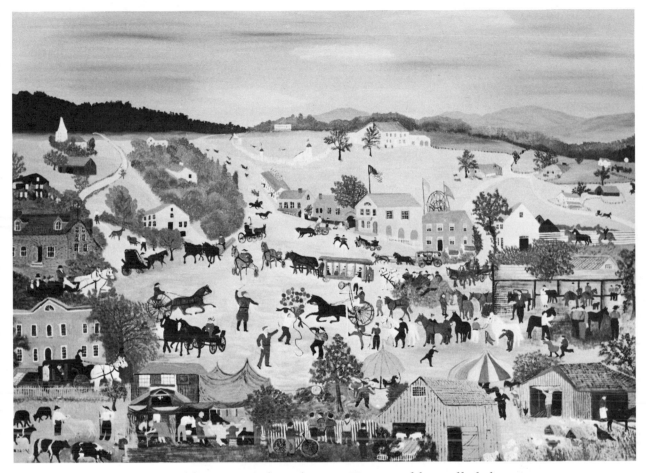

Country Fair, *painted by Moses when she was 90 years old, recalled the many expositions at which she had won prizes for her canned fruit and baked goods.*

the inhabitants pleasant. By now, in fact, she felt more like a Virginian than a New Yorker; although she was always glad to see visiting relatives from the North, she was happy right where she was.

But Thomas Moses missed his native soil. Over the years, he had made several trips to New York State, returning each time more homesick than ever. Then, in 1905, the Moseses heard of a good farm for sale near Eagle Bridge, New York. At the same time, they received a tempting offer for their farm. The combination was irresistible; Anna Mary agreed that it was time to move. Late in the year, she wrote afterward, "we chartered a railroad car, and we brought the stuff we had—a piano and beds and necessary things." Among the necessaries were a cow and a coop full of chickens, which shared the rail-

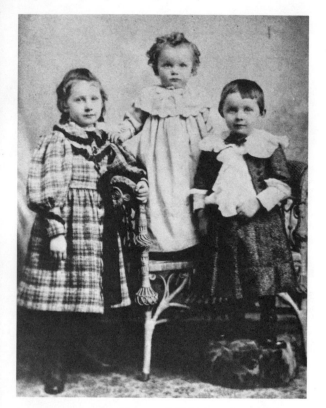

Among the Moses children who survived childhood were Winona (left), Loyd (right), and Forrest. To the sorrow of the Moseses, 5 of their 10 offspring died in infancy.

bined assets amounted to $600; they returned as proud and prosperous parents of five children and owners of one of the finest farms in the county.

Nevertheless, Anna Mary Moses was not at ease in the beginning. "I was first very homesick," she remembered. "It seemed to me as though I was down in a swamp all the time. While in Virginia we were 1600 feet above sea level; here we are only 300 feet above. Some call this a pretty valley, but give me the Shenandoah Valley every time!" Her children, too, had some difficulty adjusting to their new home. "They were called rebels,'" said their mother, "because they believed in the South, in the theories down there. Their Yankee cousins didn't know anything about all that, and it caused a kind of family feud."

After receiving a flurry of visits from relatives, she recalled, "My husband and I just dropped back to where we had left off." Soon she had the house cleaned and redecorated, and the family settled back into the familiar routine of farm life. In her autobiography, she outlined a typical day: "Before the sun was up, I would dress and build the fire, and put on the tea kettle for hot water, go out to the hen house, feed and water the chickens, come in and get breakfast.... Then for five to six long hours in the field and in the house. Then a good dinner and back to work again until sundown, then supper and the milking; and then ... with some there would be a reading of a chapter in the Bible and a prayer, then to bed till another day."

road car with their owners during the long journey north.

"Going up home—it was, of course, new country to all my 'rebels,'" recalled Anna Mary Moses of her arrival in Washington County. She told her 17-year-old daughter, Ona, "I don't think a bit has changed since we left here." But the Moseses themselves had changed. Anna Mary and her husband had left New York as a newly married hired man and hired girl whose com-

The Moses children, said their mother, "were always full of pranks, always in mischief with their young friends." She described one "water battle" in which the young people fought so enthusiastically that water was soon cascading down the back stairs and into the dining room. When a visiting friend expressed shock over such behavior, Anna Mary said she wanted her youngsters "to have fun while they were young and could; it would be something to laugh about when they were old." Hers, she said, "was a rollicksome, happy house," where the children's father "would join in with them; he really was one of them."

Anna Mary Moses had always admired her husband for being a "forward-looking man." Interested in the latest farming techniques, he crossbred two types of sheep to create a new breed ideally suited to the upstate New York climate, and he was one of the first farmers in the state to plant alfalfa and Idaho potato crops. And Thomas Moses—like his wife—had progressive ideas about education.

At a time when few local children attended school past the sixth grade, the Moseses sent theirs to high school and beyond. After she finished high school, Ona stayed home to help her mother, but Anna enrolled in nursing

Gathered at the Moseses' Virginia home in 1892 are (at left) Thomas and Anna Mary; their children; Thomas's sister Mattie and her husband; and two hired hands.

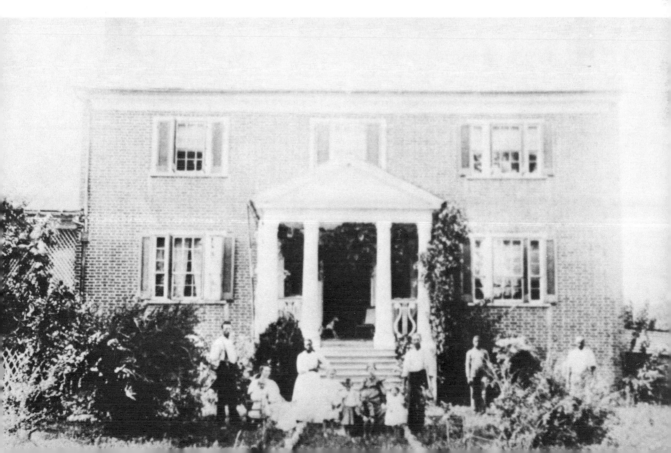

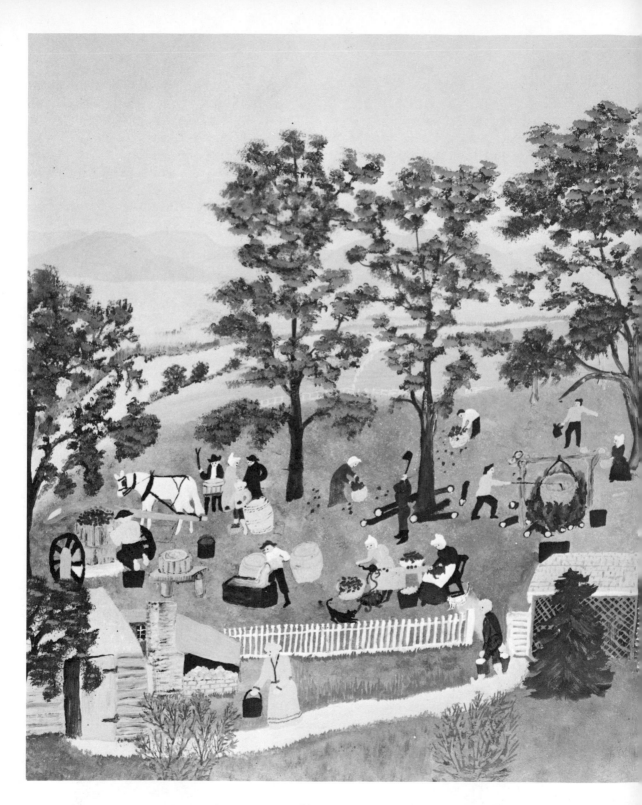

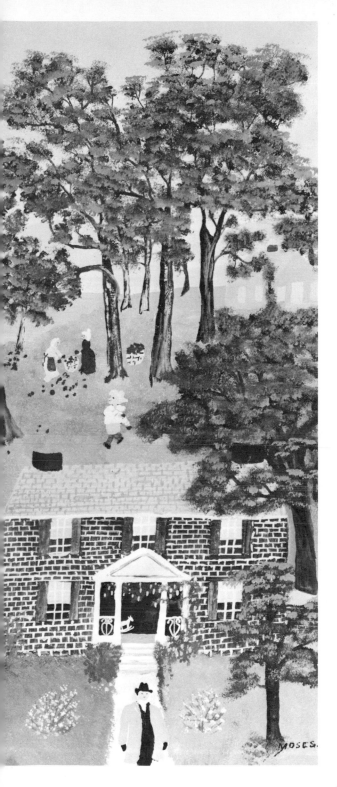

school and the boys went to agricultural college. Loyd, Forrest, and Hugh, who returned home with new farming knowledge and technology, gradually took over the hardest work on the family acres. Local people, noted Anna Mary proudly, considered their place "quite a model farm."

As the years passed, the Moseses added modern machinery to their farming equipment. "The iron age came on very fast," recalled Anna Mary. "In 1911 there was lots of talk about a new invention, airplanes. Sometime later I saw my first. And my first movie I saw in Syracuse in 1914, that was grand." The Moses family bought its first automobile—an Overland—in 1913, the same year that Anna Mary visited Albany and saw electric lights for the first time. By then, the children had begun to marry: Ona in 1910, then Forrest, Loyd, Anna, and finally Hugh. Married at the age of 19, Hugh brought his bride "right back home to live with us," noted his mother.

Soon after her 58th birthday, Moses decided to wallpaper her living room. The work was going well, but when she came to the fireboard—the wooden plank placed over the fireplace in summer—she ran out of wallpaper. "So I took a piece of paper and pasted it over the board," she reminisced. "I painted it a solid color first, then I

Grandma Moses set her lively 1947 painting, Apple Butter Making, *on the Virginia farm where she and her family had lived half a century earlier.*

45

history had begun: "That," said Anna Mary Moses, "was my first large picture." (Decades later, Moses rediscovered the painting, which was eventually acquired for the Grandma Moses archive at the Galerie St. Etienne, New York.)

In 1920, 60-year-old Anna Mary Moses recorded another milestone: Like millions of other American women, she voted for the first time. The 1920 election marked the triumph of the woman suffrage movement, which had spent decades battling for equal electoral rights for women. "I think women should vote," Moses wrote in her autobiography. "They have to make a living just the same as the men do, so why should they not have a say-so?" Warming to her subject, she added firmly, "Some women are more capable [of] holding office than some men are."

Moses also wrote about her growing interest in art. "I had always liked to paint, but only little pictures for Christmas gifts and things like that," she recalled in her autobiography. When she was in her sixties, she specialized in "worsted pictures"—scenes she designed and stitched onto cloth— and small pictures she made for her grandchildren. One day in late 1926, the 66-year-old Moses (now affectionately called Grandma by friends and family) received a surprising compliment: "That's really good, that behind the stove," said Thomas Moses, pointing to a picture of Little Boy Blue. His wife said, "Oh, that isn't much," but Thomas insisted, "No, that's real

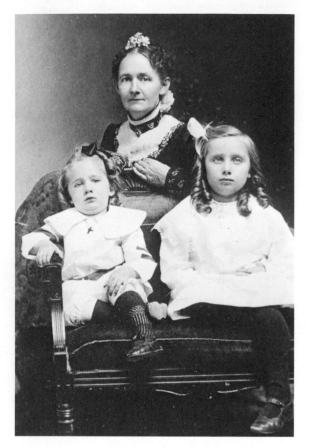

Anna Mary Moses, 44, proudly displays her two youngest children, Anna and Hugh, in 1904. A year later, the Moses family left Virginia for Eagle Bridge, New York.

painted two large trees on each side of it, like butternut trees. And back of it I did a little scene of a lake and painted it a yellow color, really bright, as though you were looking off into the sunlight . . . I daubed it all on with the brush I painted the floor with." Several years later, Moses repapered the room, covering up the painted board. Nevertheless, a new chapter in American art

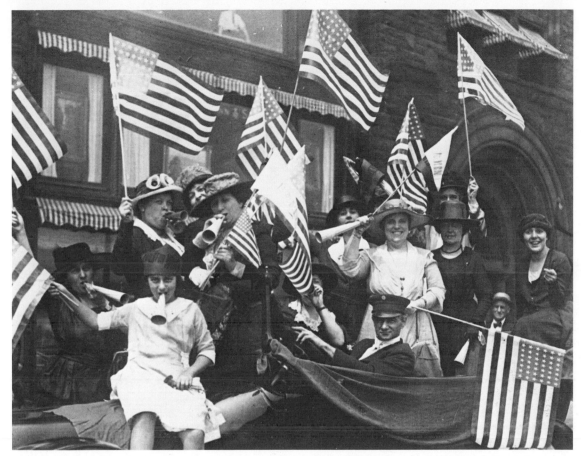

Exuberant suffragists stage a victory parade in 1920. That year, millions of American women, including Grandma Moses, voted for the first time.

good." Anna Mary Moses would cherish these words of praise for her art; they were not only among the first she would hear from her husband of 40 years, they were among the last.

Standing at her kitchen window a few weeks later, she watched a snowstorm raging outside as she waited for Thomas to bring in a load of firewood. When he entered without the wood, she asked if he was sick. "No, but I'm so cold," he replied. "Sit down by the fire," she instructed, "and take off your boots." After she had made him a steaming pot of ginger tea, she picked up his boots, surprised by their weight. "I hope you never have to wear those heavy boots again!" she exclaimed. Thomas took a brief nap, then awoke with the words, "It's dark." Agreeing that it had been dark all day, Grandma Moses lit the lamp. "It turned dark all at once," said her husband.

Frightened, she went to look for her son Hugh and send him for the doctor. Then, she wrote later, "I came back into the room and went to Thomas, and I knew the minute I got back he

Grandma Moses painted her first large work (above) on a wooden fireplace cover. To create it, she said, she used "the brush I painted the floor with."

was gone." When the doctor arrived, he pronounced Thomas Moses dead of heart failure. "If I'd been right here," he told the shocked Anna Mary, "I couldn't have saved him."

Anna Mary could almost hear some of her last conversations with Thomas. Only a few weeks earlier, he had suddenly said, "I don't mind dying." Startled, she responded quickly, "You are not going to die, you are perfectly well!" But Thomas ignored her remark. "I can't bear the thought, to go and leave you here," he said. "But if there is such a thing as coming back to this earth, I will come back and watch over you."

Many years later Grandma Moses wrote, "He said he would never leave me, and I don't think he ever has."

Then, reflecting on her art, she said, "I never thought that I would do such work; I never know how I'm going to paint until I start in. Something tells me what to go right on and do. It was just as though [Thomas] had something to do about this painting business. I have always thought ever since, I wonder if he has come back, I wonder if he's watching over me."

On the day of Thomas's funeral, the Moses home was crowded with grieving friends and relatives. Comforting them as well as herself, Anna Mary said she had no complaints; she and her husband had gotten "the best out of what life offered." After the services, she returned to her usual busy life, submerging her sorrow in cooking, cleaning, sewing—and painting. During that dark time, Grandma Moses could have no idea that she would someday be hailed as "one of the key symbols of our time" and "an artist whose paintings reveal a quality identical with genius."

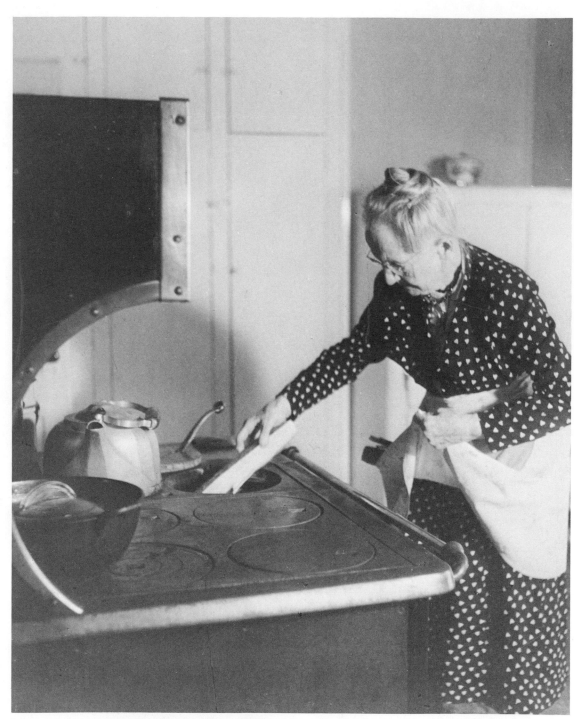

Moses stokes a fire in the old-fashioned stove at her Eagle Bridge, New York, home. She moved there with her family in 1905.

FOUR

The Artist Emerges

When her husband died in 1927, Grandma Moses was 66 years old. Advancing years, however, had diminished neither her zest for life nor her boundless energy. Her son and daughter-in-law Hugh and Dorothy had taken over most of the heavy work around the family farm, but Moses still felt the need to fill up every minute of the day with useful activity. "Work of any description," she believed, "adds to one's happiness."

She had always prided herself on her canned fruits and vegetables and her homemade preserves. Competing against other first-rate cooks, she had won many blue ribbons at Virginia country fairs, and she had received first prize for her Early Golden apple jelly at the 1920 State Fair in Albany, New York. She still spent hours in her kitchen, standing over a steaming kettle and stirring her flavorful mixtures. But as time passed, she began to spend even more time on artistic pursuits.

She continued to make fancywork, devoting several hours each day to embroidering colorful pictures for her 11 grandchildren. Needlework, however, became increasingly difficult for Moses, who suffered from arthritis of the hands. A painful disease that often causes swelling and stiffness in the joints, arthritis usually gets worse with age. Modern doctors can reduce its pain and swelling with certain medications, but not even this limited relief was available to Grandma Moses in the upstate New York of the 1920s.

Finally, recalled Moses, "I could not handle a large [embroidery] needle any more." After a day's work, she tried to deaden the pain in her hands by wrapping them tightly with scarves, but

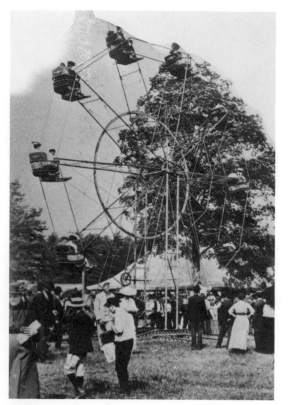

Ferris wheel riders soar over their neighbors at the 1906 Washington County Fair. Moses often came away from such festivals with blue ribbons for her preserves.

times a day. Despite the book's age, Grandma Moses followed its advice, faithfully drinking the strange concoction every day for three months. Although few modern doctors would prescribe such a potentially dangerous mixture, it worked for Moses. Her fingers remained stiff, but "all of a sudden," she said, "there were no pains any more."

Except for the arthritis, she was in excellent health as she entered her seventies. This was not the case, however, for her daughter Anna. In December 1932, 37-year-old Anna, who lived with her husband and children in Bennington, Vermont, called Moses. Anna had been stricken with the flu; could her mother come up and help out for a while? Moses went at once to Bennington, and Anna soon seemed to recover. Then, in the middle of a Christmas party, she suddenly collapsed. "She only lived a few days after that," wrote her sorrowful mother. Just before she died, Anna had promised her little girl a birthday party. In her typical no-nonsense fashion, Moses gave the party soon after her daughter's funeral. For the next two years, until Anna's husband remarried, Moses stayed on. "I took care of the house and the two children, the same as I would have at home," she reported matter-of-factly.

When she returned to the large house she shared with Hugh and Dorothy in Eagle Bridge, she and her daughter-in-law decided to increase their income by raising chickens and taking in boarders. In her spare time, Moses continued to embroider pictures, although her ar-

still, she said, "at night I couldn't sleep on account of the aching, just like a toothache."

One night, she "got desperate," jumped out of bed, and went in search of "the doctor book," a medical text that had been in her family for generations. Published in 1833, the *Family Adviser, Philosophy of Diseases* offered a recipe to ease the pain of arthritis: three cups of milk, each diluted with five drops of turpentine, taken three

"Mt. Nebo," the Moses farm in Eagle Bridge (above), was named for the spot from which, according to the Bible, Hebrew prophet Moses first viewed the promised land.

A portrait of the house where Anna Mary Moses lived from 1905 until 1951, Mt. Nebo on the Hill *is among dozens of pictures the artist embroidered.*

thritis made the work slow and difficult. Watching her sew one day, her younger sister Celestia suggested it might be easier to paint pictures than to stitch them. Moses had done very little painting since her early youth, but she was attracted to the idea. Now, in her mid-seventies, she began to paint, "for pleasure, to keep busy, and to pass the time away," she said. But, she observed later, "I thought of it no more than of doing fancywork."

She made use of materials she found around the farm. "For her first picture," recalled her daughter-in-law, "Grandma used a piece of canvas which had been used for mending a threshing machine cover, and some old house paint." She used brushes left over from painting the house and barn; for fine details, she employed toothpicks or the ends of kitchen matches.

When she and her husband saw Moses' first painting, said Dorothy, "We told her it was very good and to try to paint more—which she did." For her

next effort, Moses bought a few cans of regular house paint at the local hardware store. Then she branched out and ordered several tubes of oil paint and real artists' brushes from the Sears, Roebuck catalog. "Painting," she discovered, "is a very pleasant hobby, if one does not have to hurry. I love to take my time and finish things up right."

For her work surface, Grandma Moses used an old "tip-up" table. Made by one of her ancestors 150 years earlier, the table had a hinged top that could be folded down when it was not in use. Discovering the tip-up table in the cellar where it had been stored for more than a century, one of Moses' relatives had given it to her. She had painted landscape scenes on its legs, covered the top with a collage of postcards, and used it as a flower stand. Now she found that it made a sturdy easel.

Although she had painted her first picture on canvas, Moses preferred to use Masonite, a type of construction board made of compressed wood fibers; such material, she said, "will last many years longer than canvas." To prepare the Masonite for painting, she sealed the surface with linseed oil, then applied three coats of flat white paint. This, she said, was "a Scotch idea," jokingly referring to the stereotyped thriftiness of the Scots. "With two coats, the dark [color of the board] would strike through in some places," she explained. "Three give it body, so when you start to paint the picture, you don't have to put on so much of the colored paint. The tube paint is quite expensive, and you have to use it accordingly."

Moses, who believed that "a picture without a frame is like a woman without a dress," insisted that "frames should always blend with the paintings for best effect." The size of her paintings was determined by the size of the frames available to her. "Before I start painting," she said in her autobiography, "I get a frame, then I saw my Masonite board to fit." She gave a true farmer's explanation for this practice: "I always thought it a good idea to build the sty before getting the pig; likewise with young men, get the home before the wedding." Good frames, she noted, were not always easy to come by in Eagle Bridge. If she found that one she liked was in a dilapidated condi-

Scenes like this one—a 1907 automobile standing alongside an East Hoosick farmhouse—formed the store of memories on which Moses based her "old-timey" paintings.

tion, she simply took out her hammer and nails and rebuilt it.

Later, when asked how she chose a subject for her paintings, Moses said, "I like pretty things the best; what's the use of painting a picture if it isn't something nice? So I think real hard till I think of something real pretty, and then I paint it."

The "pretty things" that came to Moses' mind were almost always scenes from her past. Unlike some older people, she found the future far more exciting than "the good old days," but she had an unusually retentive memory. In the course of her almost eight decades of life, she had "filed away" thousands of sights and experiences, each of which she could recall in precise detail. When she was nearly 90 years old she wrote, "What a strange thing is memory and hope; one looks backward, the other forward. The one is of today, the other is the tomorrow. Memory is history recorded in our brain; memory is a painter; it paints pictures of the past and of the day." When Grandma Moses painted, she saw images from her past in her mind's eye as clearly as if they were outside her window.

Moses, said art historian Jane Kallir in her 1982 book *Grandma Moses: The Artist Behind the Myth*, "saw nature as a farmer sees it, and she saw it as an artist. In the end, the two points of view turned out to be very similar." Almost all of Moses' early paintings showed what she called "old-timey things, historical landmarks of long ago, bridges, mills, and hostelries, those old-time homes." She would paint these structures from a "daydream," then surround them with landscapes. Although she did almost all her work in her bedroom, she sometimes left her tip-up table to reexamine the colors of nature outside.

"Often I get at loss to know just what shade of green, and there are a hundred trees that have each three or four shades of green in them," she wrote in her autobiography. "I look at a tree and I see the limbs and then the next part of the tree is a dark, dark black green, then I have got to make a little lighter green, and so on. And then on the outside, it'll either be a yellow green, or whitish green, that's the way the trees are shaded."

The artist knew exactly what colors she wanted in her paintings, but not everyone agreed with her perceptions. "They tell me that I should shade [the snow] more, or use more blue, but I have looked at the snow and looked at the snow, and I can see no blue," she wrote. "Sometimes there is a little shadow, like the shadow of a tree, but that would be gray, instead of blue, as I see it." She also defended the colors she occasionally used for the sky: "I love pink, and the pink skies are beautiful. Even as a child, the redder I got my skies with my father's old paint, the prettier they were."

Moses, who usually titled her paintings after she completed them, always wrote the name of each picture on its back. The titles were simple and descriptive: *Down in the Glen*, *The Old Red Sleigh*, *Backyard at Home*, and

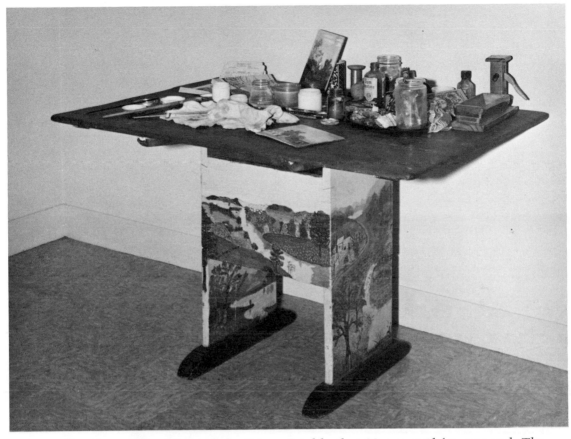

Art supplies cover the surface of the "tip-up" table that Moses used for an easel. The table's legs are decorated with Moses' landscapes.

Farm Along the River are typical. According to Moses authority Otto Kallir (grandfather of Jane Kallir), each title "bespoke the artist's involvement with a given theme. One felt that what she tried to express was always a personal experience, what she depicted was always something she had been part of. Whether the picture was of a washday or a Sunday, it was *her* washday, *her* Sunday."

Occasionally, Moses painted scenes that were not inspired by her own memory. In these cases, she added inscriptions or lines of poetry. For example, on the back of an early painting entitled *Missouri*, she wrote part of a favorite poem:

Where the muddy Missouri rolls on to the sea
 Where man is a man, if he is willing to toil,
 And the humble may gather the fruit of the soil.

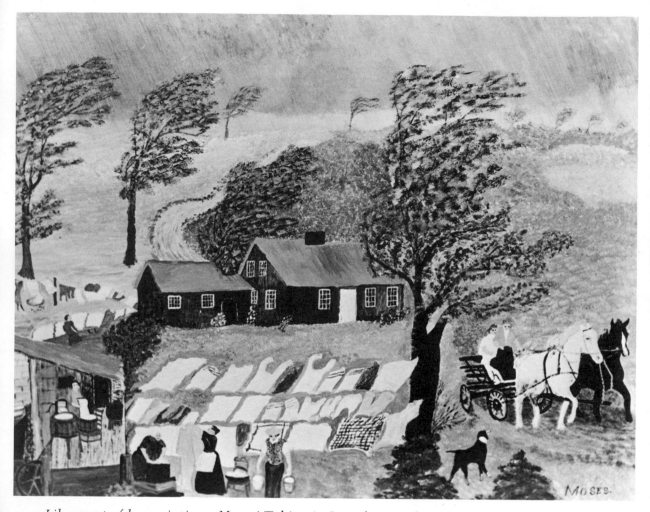

Like most of her paintings, Moses' Taking in Laundry *was based on personal experience. If a picture showed a washday, noted one expert, "it was her washday."*

When she started painting in her seventies, Grandma Moses had no thought of becoming a professional artist: "I thought every painting would be my last one," she said. Nevertheless, she kept on painting, both because she enjoyed it and because the results gave pleasure to her friends. At the urging of her family, she even entered a few local competitions. At one fair, she exhibited several paintings, along with some of her canned fruit and preserves. "I won a prize for my fruit and jam," she recalled with amusement, "but no pictures."

In 1939, Carolyn Thomas decided to start a "woman's exchange" in the Hoosick Falls drugstore. Here, she thought, local women could bring their

specialties—needlework, paintings, and other handcrafted items—to exhibit and, perhaps, sell. When Dorothy Moses heard about Thomas's plan, she brought a group of her mother-in-law's pictures to the store. Thomas priced them at about two dollars apiece and placed them in the window.

"This is where the ball started rolling for Grandma," Dorothy Moses said later. "One day Louis Caldor, an art collector from New York who was passing through Hoosick Falls, stopped at the drugstore and was very much amazed at the wonderful collection. He went in and asked all about the pictures and who the artist was and where she lived. Later he came here and met Grandma. He asked her to paint some pictures for him, which she did."

For 78-year-old Anna Mary Moses, life would never be the same again.

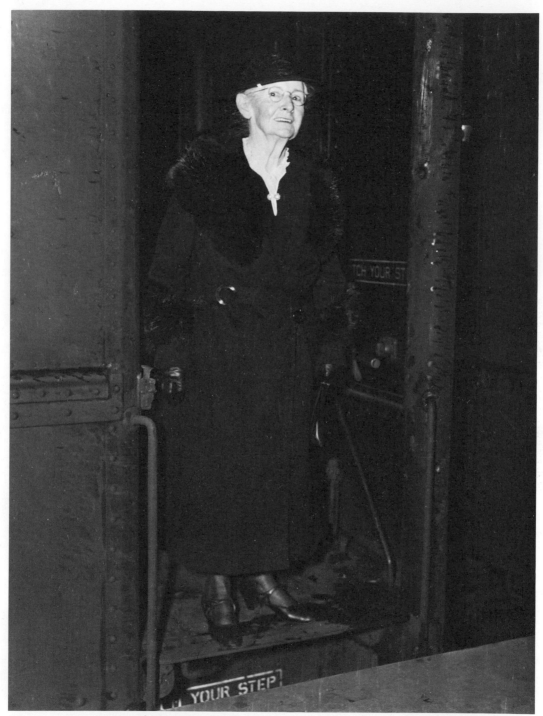

Moses arrives in Manhattan in 1940. She found the city's pace dizzying but, she said, she appreciated the "bother" its residents took to welcome her.

FIVE

Becoming a Celebrity

Louis Caldor walked into a drugstore for a bite to eat, walked out with an armful of paintings, and opened a new chapter in the history of modern American art. Without his spur-of-the-moment decision to stop in Hoosick Falls, and without his hunch that he had spotted a true American original, Grandma Moses' enormous talent might have remained undeveloped and unknown.

But recognizing talent was one thing; persuading the art world to acknowledge it was another. Today's art lovers are indebted to Caldor, not only for his good judgment but for his remarkable persistence. After he returned to New York City with Moses' paintings, he brought them to a series of prominent art dealers and galleries. Not one was interested. Many refused to look at the pictures at all, scoffing at the thought of promoting the artwork of an old woman—an unknown, untrained old woman at that.

A few art experts did condescend to examine the paintings. Most of them agreed that Moses' work was "nice" but said it could not be taken seriously. After all, they pointed out, it lacked professional technique, it did not reflect mainstream modern art, and it did not deal with contemporary American themes.

Some people in Caldor's situation would have given up after the first 10 or 20 rejections. But for more than a year, from the spring of 1938 to the fall of 1939, Caldor devoted much of his spare time to forwarding the career of a woman he barely knew. He also wrote her many encouraging letters. "Just be yourself and express yourself, and keep on painting the way you like to paint,

and what you like to paint," he told her. "Sooner or later I will be able to publicly justify my opinion of you," he added, "and bring you some measure of respect and recognition for your efforts." Along with the letters, Caldor sent Moses an array of painting materials, and he made several trips from New York City to Eagle Bridge to pick up new examples of her work.

His first breakthrough—a modest one—occurred in the fall of 1939, when

When Manhattan gallery owner Otto Kallir (below) first saw Moses' paintings in 1940, he was struck by their "atmosphere of compelling truth."

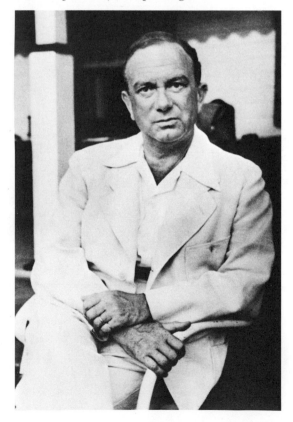

Manhattan's Museum of Modern Art scheduled a show entitled "Contemporary Unknown American Painters." As soon as Caldor heard about the exhibit, he hastened to the museum with a selection of Grandma Moses' pictures. To his delight, the exhibit's organizer agreed to feature three of them—*Home*, *In the Maple Sugar Days*, and *The First Automobile*—in the exhibition.

Inclusion in the show was gratifying, but it did little to advance Moses' career. Not open to the general public, the exhibition sparked limited interest. After running for a month, it closed, and Moses' paintings were returned to Caldor with a brief note of thanks. Still undaunted, he continued to trudge from one gallery to another with Moses' paintings. Then, six months after the museum show, he heard about the Galerie St. Etienne, a new exhibition space whose proprietor was interested in primitive art.

The gallery was owned by Otto Kallir, a well-known art dealer from Austria. Kallir, who had left his native land when it was taken over by Adolf Hitler's Nazi armies, had operated galleries in Vienna and Paris before opening his New York City showroom in 1939. His primary interest was in 20th-century Expressionist art—works that depict their subjects in emotional rather than realistic terms—but he was also intrigued by so-called primitive, or "naïve," painting. When Caldor brought him a dozen of Grandma Moses' small pictures, some of them painted, others embroidered, the dealer was impressed.

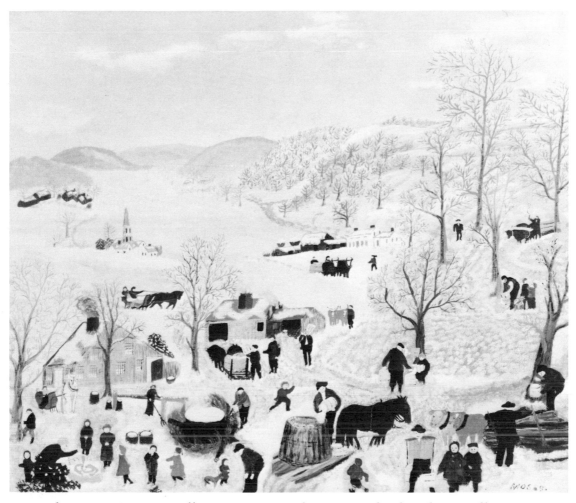

Painted in 1943, Sugaring Off *is among several Moses works that depict villagers collecting maple syrup, a favorite theme of the artist.*

"Their artistic quality varied greatly," he recalled later, "but quite a few were very good."

Kallir was particularly struck by one painting, *Bringing in the Maple Sugar*, which shows adults collecting maple sap and unloading firewood, children playing in the snow, and a team of oxen approaching. "It all added up to a well-balanced scene of animated activity," observed Kallir in his 1973 book *Grandma Moses*. He thought the figures in the painting were "rather clumsy," but the landscape, he said, "was painted with astonishing mastery. Though she had never heard of any rules of perspective, Mrs. Moses had achieved an impression of depth

. . . creating an atmosphere of compelling truth and closeness to nature."

Kallir told Caldor he wanted to see more of Moses' work, but the engineer apologetically said he would have to wait: Caldor worked until eight o'clock, and the rest of the paintings were in his car, parked on the outskirts of the city. "Eager to get a more definite impression," recalled Kallir, "I agreed to this rather strange way of presenting an artist."

That night, the two men drove out to the parking lot where Caldor kept his car and inspected the pictures by the beam of a flashlight. Kallir's initial enthusiasm increased. "I told Mr. Caldor," he said, "that I would be willing to give the artist a one-man show at my gallery, on condition that the choice of works be left to me."

Back at his gallery with the paintings, Kallir reviewed them and selected a total of 34, all but 2 of them small, for the show. In the fall of 1940, New York City art critics and collectors received an invitation that read:

The Galerie St. Etienne
Requests the Honor of Your Company
At the Preview of the Exhibition
WHAT A FARM WIFE PAINTED
Works By Mrs. Anna Mary Moses

The exhibition opened on October 9, 1940, about a month after Grandma Moses' 80th birthday. "The general reaction was surprisingly favorable," recalled Otto Kallir. "The simplicity and candor of the pictures, the artist's ability to express in a clear, uncomplicated way what she had to say, established immediate contact between work and beholder."

Kallir had priced the paintings modestly—between $20 and $250—but only 3 were sold. Nevertheless, newspaper and magazine reviews were generally positive, and the show attracted large crowds; New Yorkers were curious about this octogenarian who had suddenly materialized on the art scene. Not present at the opening, however, was the artist herself: Kallir had invited her, but Moses declined, patiently explaining that she had already seen all the pictures.

Meanwhile, Gimbel Brothers, then the world's largest department-store chain, was organizing a Thanksgiving Festival at its Manhattan branch. Spotting a good publicity idea in Grandma Moses and her colorful paintings, the store's directors arranged to borrow her paintings for their own exhibit. Because the auditorium at Gimbel Brothers was much larger than Kallir's gallery, a number of pictures not seen at the Galerie St. Etienne, including embroidered scenes, were added. The store invited Grandma Moses to come to the event, and this time—somewhat nervously—she accepted.

Moses had visited New York City only twice since she passed through in 1905, on her way back from Virginia. "What anticipation and vexation, what commotion and confusion!" she wrote about preparing for the trip to the big city. Accompanied by her friend Carolyn Thomas, she arrived in Manhattan on November 13, 1940. At Louis Caldor's suggestion, she brought along

(continued on page 73)

SELECTED WORKS
BY GRANDMA MOSES

Grandma Moses' pictures "depict the rich fabric of the national experience," according to Dr. Robert Bishop, director of New York City's Museum of American Folk Art. Although she occasionally painted imaginary subjects, such as *The Guardian Angel* (c. 1941), Moses preferred to portray scenes observed during her many years of rural life. Popular themes—maple sugaring and catching the Thanksgiving turkey, for example—appear repeatedly in her work, but she never painted the same picture twice. Whatever the subject, every painting she made found its way to the heart of the American public. Moses was, says Dr. Bishop, "a painter of the people and for the people."

Grandma Moses: *On the Road to Greenwich.*
Before 1941. Oil on cardboard.
(Kallir 26.) Private collection,
courtesy Galerie St. Etienne, New York.

Grandma Moses: *The Guardian Angel.*
Before 1941. Oil on pressed wood.
(Kallir 29.) Grandma Moses Properties Co., New York.

Grandma Moses: *The Childhood Home of Anna Mary Robertson Moses.*
1942. Oil on pressed wood.
(Kallir 160.) Private collection,
courtesy Galerie St. Etienne, New York.

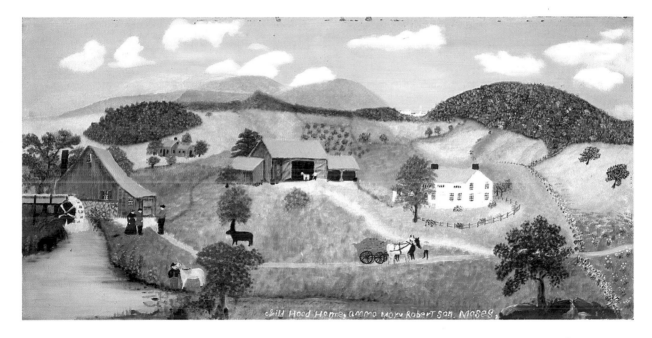

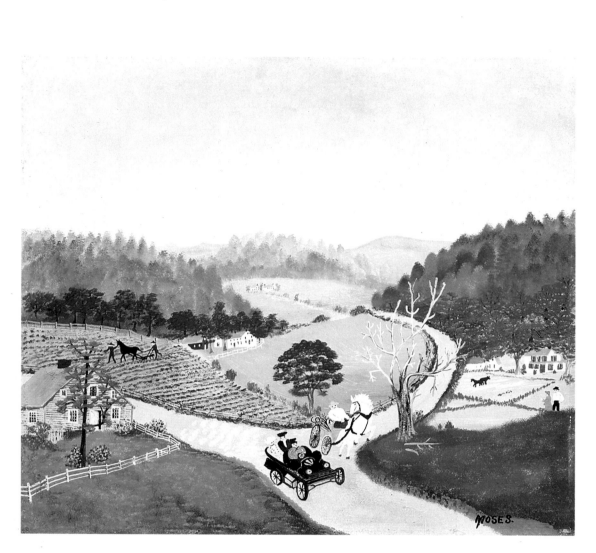

Grandma Moses: *The Old Automobile.*
1944. Oil on pressed wood.
(Kallir 442.) Private collection,
courtesy Galerie St. Etienne, New York.

Grandma Moses: *Christmas at Home.*
1946. Oil on pressed wood.
(Kallir 586.) Private collection,
courtesy Galerie St. Etienne, New York.

Grandma Moses: *Hoosick Valley (from the Window)*.
1946. Oil on pressed wood.
(Kallir 611.) Private collection,
courtesy Galerie St. Etienne, New York.

Grandma Moses: *A Beautiful World.*
1948. Oil on pressed wood.
(Kallir 787.) Private collection,
courtesy Galerie St. Etienne, New York.

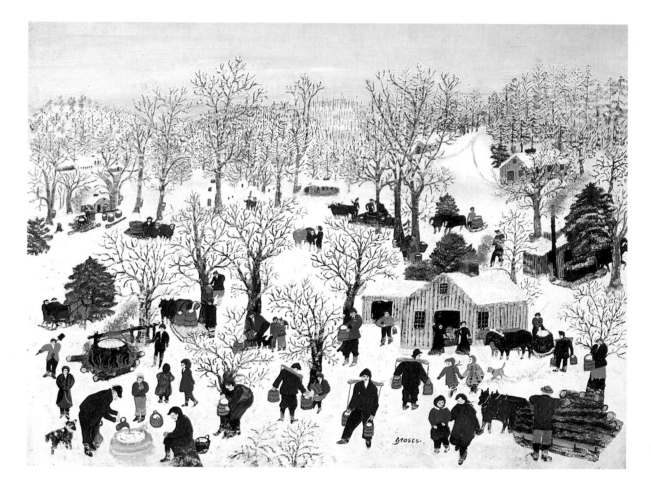

Grandma Moses: *Sugaring Off.*
1955. Oil on pressed wood.
(Kallir 1166.) Private collection,
courtesy Galerie St. Etienne, New York.

(continued from page 64)

some samples of her preserves and homemade bread. Remembering that she had won many state-fair prizes for her cooking, but none for her painting, she expected to talk to people about jam.

Arriving at the store, Moses found hundreds of people who had come to see her paintings and hear her talk about her art. She described the experience in her autobiography:

> Someone handed me one of those little old ladies' bouquets and then someone pinned something on me, it felt just like a black bug, but I couldn't look down. It was a microphone, I was on the air. They took me by surprise, I was in from the back woods, and I didn't know what they were up to. So while I thought I was talking to Mrs. Thomas, I spoke to 400 people at the Thanksgiving Forum in Gimbel's auditorium.
>
> Afterwards, oh it was shake hands, shake, shake, shake—and I wouldn't even know the people now. My, my, it was rush here, rush there, rush every other place—but I suppose I shouldn't say that, because those people did go to so much bother to make my visit pleasant.

Before the Thanksgiving show, Gimbel Brothers had released an avalanche of publicity about Moses, labeling her "the white-haired girl of the U.S.A." and "the biggest artistic rave since Currier and Ives." When she appeared in Manhattan, she lived up to all of it: New Yorkers were charmed with the unconventional, outspoken woman from Eagle Bridge. To a reporter who asked how she liked being a celebrity, she said, "Well, people tell me they're proud to be seen on the street with me, but I just say, well, why weren't you proud to be seen with me before? If people want to make a fuss about me, I just let 'em, but I was the same person before as I am now."

After the show, Grandma Moses returned to the household and farm chores she had been performing all her life. "There is so much to do this time of year in the country," she wrote a friend. She also returned to her painting, working with increasing confidence and skill. Her early paintings had been small, most of them tightly focused on a single object: a bridge, a house, an automobile. Now, when such objects appeared in her pictures, they served as accents in a broad, sweeping landscape. One such picture is *The Old Oaken Bucket*, painted in early 1941.

A popular song of the late 19th century, "The Old Oaken Bucket" was based on a true story. Moses had heard a firsthand account of the tale 64 years before she painted the picture. As a 17-year-old hired girl, she briefly worked for an elderly neighbor, Mrs. David Burch. One day, Burch told a story about her great-uncle Paul, who had joined the navy when his sweetheart's family forbade her to marry him. At sea, Paul wrote a nostalgic poem about home, verses that later became the well-known song about the oaken bucket. Burch went on to describe the farm on which Paul had lived, a sprawling landscape that in-

With Carolyn Thomas (left), Moses calmly faces her audience at a New York department store in 1940. She said the microphone pinned to her dress felt "like a black bug."

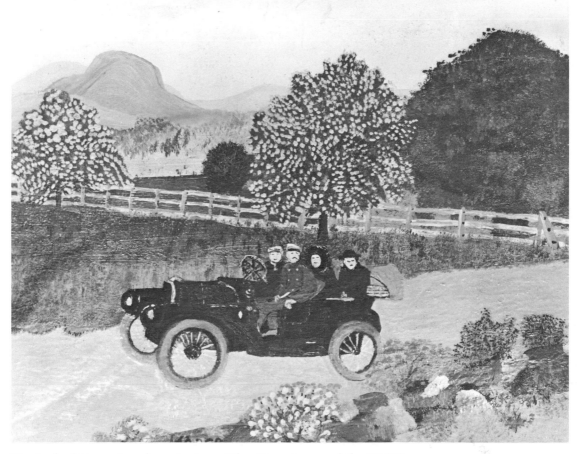

Typical of Moses' early paintings, The First Automobile *(1939) concentrated on one object. In later works, the artist created more sweeping landscapes.*

cluded strawberry fields, a shingled cottage, a dairy house, and a well with a wooden bucket.

Grandma Moses, who forgot nothing, vividly recalled Burch's description more than six decades later. "That winter [1940–41]", she wrote in her autobiography, "I had the grippe [flu], and they kept me in bed, and I planned mischief then. When I was lying there, I thought I was going to paint the story

of the 'Old Oaken Bucket,' because I knew how it originated." When she recovered from her illness, she translated the story into one of her most popular paintings.

Shortly after she finished the work, she was invited to send some paintings to Syracuse, New York, for an exhibition at the city's Museum of Fine Arts. She sent three, including her new landscape. A few weeks later, she learned

75

Moses painted the first The Old Oaken Bucket (above) in 1941. Although she later produced several versions of the popular theme, none was exactly like any other.

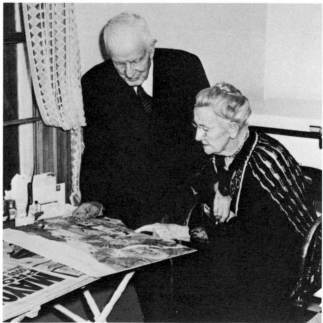

Grandma Moses and Thomas J. Watson discuss art in 1955. The two had first met in 1941, when the business tycoon bought the artist's The Old Oaken Bucket.

she had won the prestigious New York State Prize for *The Old Oaken Bucket*. The painting was bought by a millionaire: Thomas J. Watson, founder and chairman of the IBM (International Business Machines) Corp., one of the largest corporations in the United States. Watson became a lifelong friend and patron of Grandma Moses.

Winning the prize seemed to inspire Grandma Moses. In the months that followed, her admirers noticed a significant advance in her technique. In 1942, she completed a landscape entitled *Black Horses*, a painting that deeply impressed Otto Kallir. He called it a "turning point" in his evaluation of the artist. "If up to that time I had looked upon Grandma Moses' work as interesting and appealing folk art," Kallir wrote later, "I suddenly realized that here was an outstanding painter. Her progress in just two short years was astonishing. . . . In *Black Horses*, a new conception seems to have emerged, as though the artist's eyes had been opened to broad vistas of nature."

Black Horses, the painting that so excited Kallir, remained one of the artist's most beloved works. It shows a broad valley backed by a mountain range; in the valley are woods, hills, and fields planted with different crops. In the right foreground, two coal black horses prance, and at the left, a brown horse carrying two children enters the scene. Kallir particularly praised the picture for its "subtle blending of muted colors." The painting was part of a show of Moses' work held in late

1942 at the American-British Art Center in New York City.

As Grandma Moses' fame spread, she was besieged by uninvited visitors and requests for interviews. She was not entirely happy about being in the limelight. In a 1942 letter to Caldor, she grumbled, "I have too much of it. I have very little time to myself any more, have about made up my mind to go to my room and lock myself in and see no one." She also objected to the tone taken by some of the news stories about her. Only half joking, she told Caldor, "My boys are so disgusted they threaten to bring suit if they could find out who wrote some of those articles that were in the papers. One of their neighbors asked if it was so, that I could not read or write, being a primitive."

With increasing frequency, Moses' mail brought letters from admirers who enclosed checks and begged her to paint them a new version of a picture they liked. The paintings of which new versions were most often requested included *Over the River to Grandma's House*, *Sugaring Off*, and *Catching the Turkey*. The artist was not always pleased to get these "orders," as she called them, but she honored them. To do otherwise, she said, would not be polite. As a result, many of her paintings show similar scenes and carry identical titles. None, however, are exactly the same.

In his book about Moses, Kallir wrote that he once asked her how she managed to keep repeating the same theme

in a fresh way. She replied "that she visualized the picture she was about to paint as though framed in her window, and that she had only to imagine she was looking out on the scene either from the right or from the left and that accordingly all parts of a composition would shift into place."

Despite the "orders" for pictures, the

interviews, and the one-woman shows, Moses never became self-important about her art. "If I didn't start painting," she wrote in her autobiography, "I would have raised chickens. I could still do it now. I would never sit back in a rocking chair waiting for someone to help me." And in a letter to one of her grandsons, she said, "I shall continue

Black Horses, *Moses' popular 1942 painting, proved that "the artist's eyes had been opened to broad vistas of nature," according to Otto Kallir.*

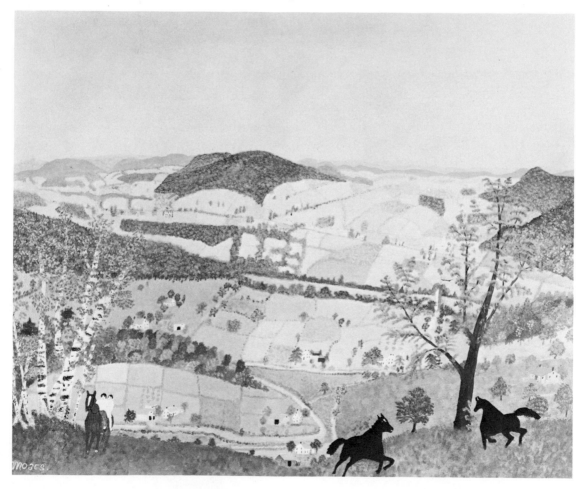

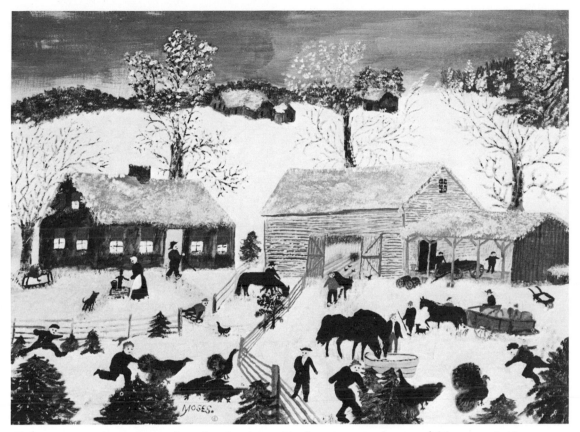

This version of Catching the Thanksgiving Turkey *is one of several Moses paintings with the same title. The theme was a favorite with the artist's fans.*

painting. I can make more money that way, and it is easier for me than taking in summer boarders."

With each new painting, Moses displayed increased mastery of her art. As her technical ability improved during the 1940s, "so did her gifts as a painter," observed Otto Kallir. "It cannot be said of many artists," he added, "that they have created a distinctive style of their own, as has Grandma Moses."

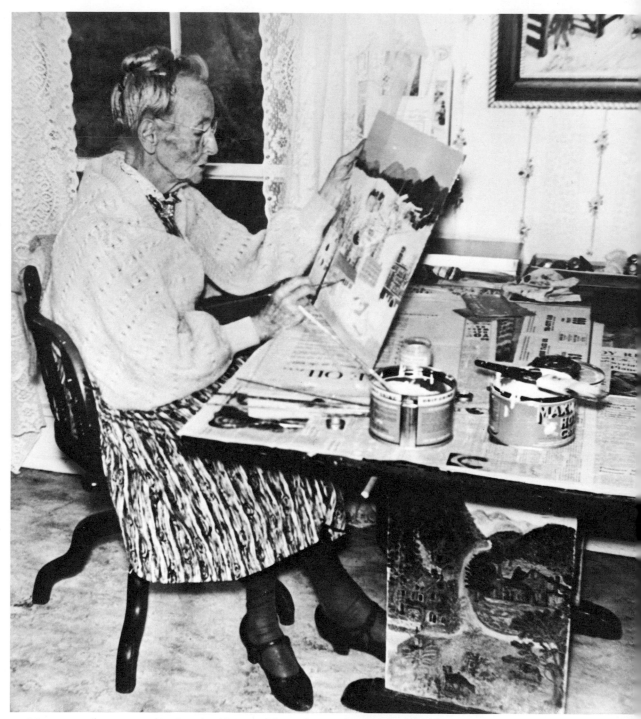

Moses works on a painting in 1948. Although art dealers begged her for large pictures, she preferred to paint on boards that fit comfortably on her tip-up table.

SIX

Stealing the Show

The United States entered World War II in 1941. During the war years, Grandma Moses continued to paint and, like millions of other Americans, prayed for a swift end to the bloodshed. "We are a wicked bunch of people," she said in a 1943 letter to a friend, "fighting and killing each other, but I do hope it will soon be over; then we can breathe in peace."

When the war ended in 1945, battle-weary Americans wanted to put thoughts of violence behind them. Perfectly suited to the mood of the time were the serene landscapes, nostalgic scenes, and life-affirming activities portrayed by Grandma Moses. As art historian Jane Kallir observed, "To a public benumbed by a pervasive fear of atomic holocaust, Moses [represented] Hope, fluttering out of Pandora's box after all its evil contents had been released."

Postwar America took Grandma Moses to its heart. She personified, said writer John Erskine, "much that Americans believe in and hope for, but rarely find in American life." Author Bernice Breen called her "an inspiration to everyone who has always wanted to do something—whether it be writing or painting or studying music—and who has never found the time to do it." Another admirer was popular comedian Bob Hope, who commended Moses for refusing to "rock away gazing backward, but remained fresh enough to tackle something new."

Moses appreciated the tributes, and in some ways she enjoyed being in the spotlight. But because she made very few public appearances, her fans gained

most of their knowledge about her from her work. Otto Kallir held two Moses exhibitions at his Galerie St. Etienne in 1944; following these shows, he allowed museums in cities and towns all over the United States to borrow her paintings for local exhibitions. He realized that Americans wanted to know

Grandma Moses and Otto Kallir, business associates as well as close personal friends, exchange a handshake on Moses' front porch in 1944.

*Dorothy Moses (right) and her mother-in-law appear in a 1946 documentary about
Grandma Moses' career. The film was nominated for an Oscar in 1950.*

Moses better, and in 1945 he decided to write a book about her, illustrated with reproductions of her paintings.

Kallir asked the artist to supply him with both an autobiographical sketch and comments on her pictures. "I found to my delight," he said later, "that her ability to express herself was not limited to painting. She had a most vivid and personal style." When Moses sent Kallir the material he requested, she enclosed a note. "Here is my life's history, can you make anything out of it?" she asked. "You see, I don't know how to go about such things."

She need not have worried. When *Grandma Moses: American Primitive* appeared in 1946, it was greeted by wildly enthusiastic reviews on both sides of the Atlantic. Demand for the

volume was so great that the publisher released a new, expanded version the following year. The book's success led to Grandma Moses' 1946 appearance—her first—on a popular nationwide radio show. The program, "We the People," was broadcast on this occasion from Eagle Bridge, New York. The show's interviewer, recalled Moses later, "was very nice and patient with me. We went over the program several times; I am a dumb Dora when it comes to such work, it is out of my line of business, but I enjoyed it, and I hope all the others did, too."

The 1946 radio broadcast, which earned Moses more admirers than ever, was followed by another form of recognition. Acting for the artist, Kallir signed a contract with a greeting-card manufacturer, allowing it to reproduce several of her paintings. Expecting good sales from its Moses Christmas Line, the company printed 4 million cards; by Christmas, it had received orders for 16 million. The following year, the giant Hallmark company took over the license, issuing many more millions of greeting cards adorned with Grandma Moses' pictures.

Asked by an interviewer what she thought about the millions of Christmas cards imprinted with her paintings, she replied, "I can't think of much to say about them. My granddaughter out in Arizona jokes a lot about them; she says I am a witch, except I ride around the country on a paintbrush instead of a broom." And when the interviewer asked her how she felt about being famous, she said, "Oh, I don't think about fame much, I keep my mind on what I am going to paint next; I have got a lot of catching up to do!"

Not surprisingly, fame meant money. Moses, who had spent most of her life watching every penny, was astounded by the prices offered for her pictures. At one point, Otto Kallir had sold several paintings for much more than Louis Caldor had paid her for them. He sent her a check for the extra money, but she promptly returned it, explaining that she been paid once, and once was enough. When a large check from Otto Kallir for greeting card royalties appeared, Moses was thoroughly baffled. Why, she wondered, would anyone pay her for something she had already sold?

Learning that Moses had not cashed the check, Otto Kallir went to see her. He explained that people who produce original creative works, such as books, paintings, and songs, are entitled to receive part of the profits when someone uses the works to make money. These profits, said Kallir, belonged to Moses. At this point, the dealer recalled later, Moses "shook her head but promised to follow my suggestion and take the check to the bank in Hoosick Falls. The next day, the cash was lying in bundles on the table, and she said she had kept her word."

Kallir suggested that Moses needed a financial manager. Her family contacted a Hoosick Falls attorney, an old friend of the Moses family. The lawyer agreed to take charge of money the artist received for the sale of her paint-

Harry S. Truman presents Moses with
the Women's National Press Club's
1949 Achievement Award. After the
ceremony, the president wrote the
artist an affectionate letter (inset).

Moses—who had received only a few years of schooling—beams as she accepts an honorary doctorate from Russell Sage College in Troy, New York, in 1949.

picture more than 2 feet square for $15. Early entries were haphazard and incomplete, but by the mid-1940s, Moses had raised both her prices and the accuracy of her record keeping. Her brother also gave her labels imprinted with her photograph; writing the title, number, and date of each picture on the labels, she pasted them on the back of all the works she sold.

The year 1949 brought Moses both sorrow and triumph. On February 10, her son Hugh died suddenly, just as his father had. The loss of Hugh, her youngest—and perhaps her favorite—child, was a heavy blow to Moses, but she took it with her usual outward calm. To Hugh's wife, Dorothy, she said, "He is better off, he is with his father now." The two women continued to share the Moses home in Eagle Bridge.

Three months after Hugh's death, Moses received exciting news: The Women's National Press Club had selected her as one of 1948's six most outstanding American women. She was invited to go to Washington, D.C., to accept the club's Achievement Award for Outstanding Accomplishment in Art. The other recipients of the coveted award included an author; a leading actress; a major industrialist; the first woman mayor of a large U.S. city; and the head of the United Nations Human Rights Commission, former first lady Eleanor Roosevelt. The award ceremony was to be held on May 14; the certificates would be presented by the president of the United States, Harry S. Truman.

ings and for royalties from their commercial use. Moses soon found herself prospering.

She was also polishing her business sense. Since 1941, when her brother Fred had given her a record book, she had kept a list of the date of completion, title, and price of each painting she sold. At first, it appears that she priced her pictures by size: The book shows, for example, that in 1943, she sold a 6-inch by 8-inch oil painting for $2, a somewhat larger one for $5, and a

Surrounded by young admirers in 1950, Grandma Moses celebrates her 90th birthday at the Institute of History and Art in Albany, New York.

Accompanied by her daughter-in-law Dorothy, Grandma Moses headed for the nation's capital. On their way, they stopped in New York City, where a crowd of reporters and photographers awaited the celebrated painter. "After surviving the ordeal of flash bulbs," reported the next day's *New York Herald Tribune*, Moses "faced a solid ring of reporters with a devil-may-care attitude. . . . She not only displayed the utter independence of the elderly but it was evident that she was having the

Museum official Jean Cassou (right) studies Moses' work at a 1950 Paris exhibition. The French art expert became one of the American artist's greatest fans.

reporters on a bit." When Moses was asked if she intended to paint "the New York City scene," she replied, "It doesn't appeal to me." The reporter asked, "You mean it doesn't appeal to you as painting material?" "As any material," she replied.

Moses had not looked forward to the press conference, but she found the experience more pleasant than she had expected. "Why, those reporters were all right," she told a *New York Times* writer afterward. "You know how chickens come running around when you go to the door to feed 'em? That's what those reporters made me think of. They were nice boys and girls."

The next day, Grandma Moses, Dorothy Moses, and Otto Kallir went on to Washington for the formal award dinner. Also attending were 700 prestigious guests, including Supreme Court justices and cabinet members. Moses, who was seated between Harry Truman and his wife, Bess, delighted the presidential couple with her animated conversation. After the banquet, Truman told Kallir he would like to see more of the painter, whose wit and charm had greatly impressed him. Moses later returned the compliment when she told reporters how much she liked the Missouri-born president. He was, she said, "a country boy like my own boys." Then, with a smile, she said, "I think he likes cows."

Bess Truman invited the award recipients to have tea with her the following day. Because the White House was being renovated, the event was held at the Trumans' temporary residence, an

Praising such Abstract Expressionist works as this untitled Jackson Pollock painting, some art critics dismissed Moses' popularity as a "fad."

old mansion called Blair House. When Moses arrived at the "ladies' tea," the first person she saw was Harry Truman, who had clearly meant what he said about seeing her again. The president and the painter enthusiastically continued their dialogue of the preceding night.

Then, recalled Moses in her autobiography, "we had a terrific thunderstorm, so we sat down on a couch to wait till the shower was over. President Truman sat beside me and said, 'Don't be afraid, as this is a large building and has many lightning rods on it.'" Moses, who had spent her life on a farm and was quite accustomed to sudden weather changes, just smiled. After a while, she persuaded the president to play the piano. "That was a delight,"

she said. "Then the shower was over, and he ordered his own car to take us to the Hotel Statler; that was an honor."

Three years later, Moses had a chance to return the honor. When the Trumans moved back into the White House after its remodeling, Otto Kallir donated one of her greatest paintings, *July Fourth*, "to the White House and to the American people." Accepted with pleasure, the picture has hung in the White House ever since.

Moses was deeply moved by her reception in Washington, but she was even more touched when she got home. A local paper reported on the occasion: "Her many friends, neighbors, and relatives in Eagle Bridge were joined by folks from all over Rensselaer County who came to welcome Mrs. Moses. . . .

Moses confers with actress Lillian Gish, star of the 1952 television drama based on My Life's History, *Moses' best-selling autobiography.*

Several hundred automobiles jammed the village's only street, as an estimated 800 persons—almost twice the population of Eagle Bridge—assembled. . . . She was back home again after receiving the largest welcome the small village could give."

Schoolchildren presented her with a bouquet of flowers and sang to her. Then, she recalled later, "the Hoosick Falls High School band played, and they escorted us home to a grand supper." It had been an exciting week for the 88-year-old artist. But, she said, "in a way I was glad to get back and go to bed that night."

Interviewed when she turned 90 on September 7, 1950, Moses said she was making plans for her 100th birthday. "I have invited a few of my friends over for a dance then," she told a reporter. Although Moses had already lived for

nine decades, her career was relatively young and her fame was still spreading, both in her homeland and abroad. Intrigued by newspaper and magazine articles about the gifted American "farm wife," European critics and art lovers were eager to examine her work in person.

In 1950, the United States Information Agency responded by sending a 50-painting Moses show to 6 European cities. Shown in Austria, West Germany, Switzerland, the Netherlands, and France, the exhibit met with overwhelming approval. Moses' "radiant art," wrote one German critic, "disproves the stupid cliché that America has no soul. Does it not speak very strongly in favor of America that this woman should have become so popular?"

Moses' popularity with the American public was unquestionable. In the early 1950s, however, the established American art scene was dominated by a style known as Abstract Expressionism. Leading practitioners of this school, who transform reality into freeform splashes of paint and complex geometric shapes, include Mark Rothko, Willem de Kooning, and Jackson Pollock. But no matter what the art establishment favored, the public liked Grandma Moses. "When she paints something, you know right away what it is," observed one newspaper columnist. "You don't need to cock your head sideways [and try to decide] if it is maybe a fricassee of sick oyster or maybe an abscessed bicuspid or just a plain hole in the ground."

Such comments irritated the critical elite. "A primitive," sneered one member of that group, "is an artist who doesn't know much about painting, but knows what people like." The "furor" over Grandma Moses, said another, was merely "a temporary excitement, a fad that [will] subside as others have." When Kallir, afraid that Moses would be hurt by such hostile remarks, wrote her a comforting letter in 1950, she responded by comforting *him*.

"Am so sorry you feel as you do about what people say," she wrote. "This is a free country, and people will talk. Let them; if we do what is right they can't hurt us.... Now please don't worry about anything as far as I am concerned, for I am all right, have taken care of myself for the past 90 years and am good for another."

Like most of Moses' painted tiles, A House *is notable for its sparing use of color and detail. The artist started working with ceramics at the age of 91.*

A year after this exchange, Moses' surviving sons, Forrest and Loyd, decided that their mother's big, old-fashioned farmhouse was too much for her and Dorothy to handle. With Moses' approval, they built her a smaller residence across the road from the old place in Eagle Bridge. Moses moved in along with her daughter Winona Fischer. Until her death in 1958, when her brother Forrest Moses took over, Fischer helped her mother with household tasks and business details. In her new house, Moses kept as busy as ever, painting pictures and putting the finishing touches on her autobiography, which she had begun at Kallir's urging. To make the job easier, Kallir had tried to persuade Moses to use a tape recorder, but she had no use for microphones. She now completed two years of work on what eventually became 169 handwritten pages of anecdotes from her more than 90 years of life.

"Of these [pages]," noted Kallir later, "only 37 deal with the years in which she had become a world-famous artist, an indication of how little importance she attached to her success as a painter, as compared to the vivid recollections of the full life she had led before as a farm wife and head of a large family."

My Life's History, a moving personal account, appeared in 1952. Immensely popular in the United States, it was soon published in England and translated into several foreign languages. Soon after its American publication, the autobiography was made into a television play starring actress Lillian Gish as Grandma Moses.

Painting pictures and writing a book apparently failed to occupy all of Moses' time. In 1951, she tried a new art form, painting on ceramic tiles. Enjoying the process of making quick sketches of, as she put it, "what the mind may produce," she created 85 painted tiles in about a year. Some of them, noted Otto Kallir, "are simple designs, almost drawings, with spare use of color; others are little paintings whose flowing colors make interesting effects on the ceramic background."

The public cherished Moses' zest for life as much as they admired her paintings. Americans saw her as living proof that hard work and a positive attitude can pay off, and that life can be rewarding for decades after the age when most people retire. The popular attitude toward Moses was summed up by a 1953 *New York Herald Tribune* editorial, printed after the artist had appeared at a forum called "New Patterns for Mid-Century Living."

"Some said that she stole the show," read the editorial. "Others were impressed with her astonishing vitality, her mental alertness, her humor, simplicity, graciousness, enjoyment of the occasion, and so on. The plain fact is, everybody felt reinvigorated while in her presence. . . . She holds within herself, in utter unawareness, the wisest secrets of life, secrets composed of many elements, yet as natural and immediate in their expression as a child's smile. While many distinguished per-

Journalist Edward R. Murrow interviews Moses on his TV show, "See It Now," in 1955. The candor of the artist's responses astonished the veteran newsman.

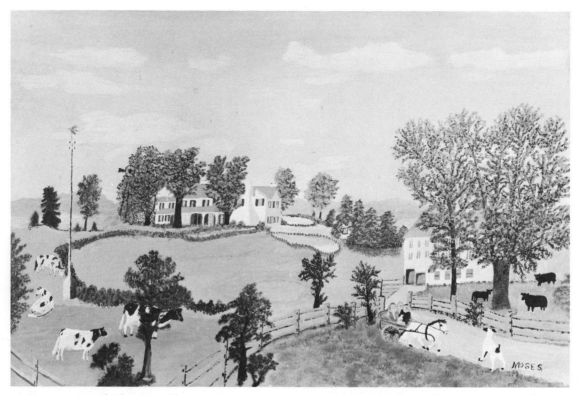

Moses painted The Eisenhower Farm, *a portrait of the president's home in Gettysburg, Pennsylvania, at the request of his cabinet in 1955. Eisenhower loved it.*

sons were appearing before the Forum, a little old lady of 93 stepped into their midst and endeared herself to all by her simple aliveness."

Two years later, in 1955, the entire nation had the rare opportunity to meet Grandma Moses and the even rarer opportunity to watch her work. The occasion was a televised interview with Edward R. Murrow, one of the nation's best-known broadcast journalists. The plans for the show, entitled "See It Now," called for Moses to answer Murrow's questions while she worked on a painting. Until then, not even Otto

Kallir had seen her paint. She worked in her bedroom, and, she had explained, she did not think it was "proper" for a man to enter a lady's bedroom, even if it was only to watch her work.

For the broadcast, however, she agreed to have her tip-up table moved into the living room, where she would work in front of the TV cameras. When the program was filmed, Eagle Bridge was in the midst of a heat wave, "not the best time," recalled Otto Kallir, "to spend many hours under hot floodlights." Everyone, he said, "was a little tense and uncomfortable, everyone ex-

cept Grandma Moses, who remained cool and unruffled throughout." When the show aired, the audience saw an artist with a very steady hand confidently produce another beautiful painting.

Edward R. Murrow was famous for his tough interviews, but he met his match in Grandma Moses. She asked almost as many questions as he did, tried to persuade him to draw a picture, and startled him with some of her direct statements. Toward the close of the interview, he asked, "What are you going to do for the next 20 years, Grandma Moses?" Her response came quickly. Pointing upward, she said, "I am going up yonder. Naturally, naturally I should. After you get to be about so old you can't expect to go on much farther."

Murrow then asked if she worried about death. "Oh, no. No. No," she said, "you think, well, what a blessing it will be to be all united again." Some night, she added, she expected to "go to sleep and wake up in the next world." Clearly moved, Murrow said quietly,

"Well, you will leave more behind you than most of us will when you go to sleep."

Moses' appearance on "See It Now" brought her even more mail than usual, much of it from amateur artists who felt encouraged by her example. Moses had been receiving such fanmail for years. One woman, for example, had written to say she had feared her "art talent would have to be thrown aside." However, she said, "having read about you has given me great courage—I shall always try to keep it up." Another amateur artist had sent Moses a reproduction of one of his own paintings along with a note. "For Grandma Moses," it read, "from a rank amateur, with best wishes, Dwight D. Eisenhower."

President Dwight Eisenhower's cabinet members, aware that their boss loved Moses' work, asked her to paint a picture of his farm. She agreed. The resulting portrait was presented to a delighted Eisenhower on the third anniversary of his 1953 inauguration.

Seated in the parlor of her home in Eagle Bridge, Moses takes a moment to catch up on the latest news.

"She Made the World Seem Safer"

Early in 1960, Random House, a large Manhattan publisher, approached Grandma Moses with a request: Would she illustrate a new version of *A Visit from St. Nicholas*? Moses' first reaction was negative. Years earlier, she had been asked to paint a series of illustrations of Bible stories. "I say *no*," she had declared. "I'll not paint something that we know nothing about; might just as well paint something that will happen 2,000 years hence." But Clement Moore's 1823 poem—usually called *The Night Before Christmas*—was different. Moses had always loved the verses, which she could recite from memory. And even in her 100th year, she found herself unable to turn down a challenge. After thinking it over, she accepted the assignment.

"At first," recalled Otto Kallir, "she dutifully tried to follow the text, and painted scenes and objects familiar to a child's conception of Christmas—stockings hanging by the fireplace, candy canes, and toys." As she got more involved with the project, however, her imagination began to soar, and she produced a series of magical, dreamlike scenes, painted in unusually intense colors.

Although she was deeply engaged in her Christmas paintings, Moses had to put them aside in September 1960. At that point, her family—and the rest of the nation—wanted to celebrate her 100th birthday. Governor Nelson Rockefeller of New York proclaimed September 7 Grandma Moses Day, and President Dwight Eisenhower and his

Flanked by her sons Forrest (left) and Loyd on September 7, 1960, Grandma Moses prepares to blow out the candles on her 100th-birthday cake.

wife, Mamie, sent a warm letter of congratulation from Washington, D.C. From Independence, Missouri, a similar tribute arrived from former president Harry Truman and his wife, Bess. The Eagle Bridge post office was almost buried beneath the avalanche of birthday cards, letters, and gifts that came from all over the country. The Moses house overflowed with flowers, and stacks of telegrams arrived hourly.

Moses had protested the celebration but, outnumbered by her well-wishers, finally gave in. As throngs of admirers streamed through her house, she said cheerfully, "I'm going to sit right here, just so, and the others can do the work. I wish they wouldn't fuss, but it's a nice excuse for the young people to get together."

To protect Moses from stress, her family limited the number of reporters allowed to interview her. One of the lucky ones was Joy Miller of the Associated Press, whose report was printed in newspapers across the nation:

> Your impression of Grandma Moses is that she is very fragile and very old. She's sitting in the living room, looking small at one end of a big sofa. . . .

You advance hesitantly. How do you address America's best known primitive painter? . . . Is it too forward to call her "Grandma"? Do you have to shout?

But she has sighted company. Her face lights up in a gamin [mischievous] grin, her hazel eyes sparkle behind their spectacles. Her welcoming hand grasps yours with startling vigor. As she chats about this and that, the character of a remarkable woman emerges: kindly, humorous, unaffected, indomitable, with sight and hearing in admirable repair. You become aware that her seemingly frail 100-pound frame supports a spirit that's at once robust and ageless.

Birthday salutes also poured in from Europe. One of them came from Jean Cassou, former director of the Musée National d'Art Moderne in Paris. "From her small-town vantage point," he said, "Grandma Moses comes to the defense of the countryside, the empire of foliage and birds, and upholds the rights of nature. She would have us know that there is still a bit of paradise left on this earth and that art may reach out as far as it will with its most advanced branches, because it is deeply rooted in the rich soil of Grandma Moses' garden."

At her birthday party, Moses kept a promise she had made 10 years earlier: With Clayton Shaw, her family doctor and longtime friend, she danced a sprightly jig.

After weeks of centennial festivities, calm finally returned to Eagle Bridge and the artist went back to work. She completed *A Visit from St. Nicholas* two months later. The book would not be published until 1962, after the artist's death, but it would receive wide critical acclaim, and its illustrations would be hailed as some of the finest work of Moses' career. In the months following her completion of the *St. Nicholas* project, Moses finished some 25 paintings, including *Falling Leaves*, *The Deep Snow*, and *Rainbow*. The splendid pictures from this period, observed Otto Kallir, "show a changed way of painting whereby the subject matter is almost dissolved into color." These landscapes, he said, suggest "that the artist had become impatient with detail and mainly wanted to bring out the general impression of a nature scene, whether the yellow leaves of autumn or the softly falling snow."

Moses' admirers considered her keen insight into nature one of her greatest strengths. Best-selling novelist Louis

Children "nestle all safe in their beds" in Moses' Waiting for Santa, *one of a series of illustrations the 100-year-old artist made for* A Visit from St. Nicholas.

Bromfield, author of *Malabar Farm* and *Out of the Earth*, wrote that a "good farmer" who saw a Moses painting "would stop and chuckle and smile and sigh, for . . . he would know at once that Grandma Moses understood his whole small world with its glories and hard work and those quick, deep, inarticulate gusts of emotion which sweep over him at the sight of a newly born calf or a blossoming pear tree."

Moses finished painting *Rainbow* in June 1961, but by then, her legendary strength was fading. "Grandma feels good, only for her legs, they are so weak," reported Forrest Moses in a July 1961 letter to Kallir. After she had taken several bad falls, Dr. Shaw urged her to spend more time in bed, but she ignored his advice and kept on painting. One day, she told a friend, she knelt to retrieve a fallen tube of paint. "When I came to get up, I couldn't," she said. "You know, my feet dropped just like a dead duck's."

Afraid his mother would do herself serious harm, Forrest Moses finally decided to take her to the Hoosick Falls Health Center. Grandma Moses, who was not pleased by this move, made plans to leave the nursing home almost as soon as she entered it. She was especially distressed by the fact that Shaw, who insisted that she "would not rest if she had her paints," refused to let her work. At one point, according to Kallir, she hid the doctor's stethoscope. He asked her where it was, and she said, "That's what I won't tell you. I hid it. It's a forfeit. You take me back

to Eagle Bridge and you'll get back your stethoscope."

But Grandma Moses never got back to Eagle Bridge. Dorothy Moses, as she had been for weeks, was at her mother-in-law's side when Moses died peacefully on December 13, 1961. Said Dr. Shaw, "She just wore out."

Somber bulletins flashed the news around the world: Anna Mary Robertson Moses, the best-known, best-loved American artist of the 20th century, was dead at the age of 101. Tributes and expressions of sympathy poured into Eagle Bridge from all points. Moses would be missed by "those everywhere who loved simplicity and beauty," said Governor Rockefeller. "She painted for the sheer love of painting, and throughout her 101 years, she was endeared to all who had the privilege of knowing her."

Speaking for millions of his fellow citizens, President John F. Kennedy said, "The death of Grandma Moses removes a beloved figure from American life. The directness and vividness of her paintings restored a primitive freshness to our perception of the American scene. All Americans mourn her loss."

On December 16, about 100 relatives and friends of Grandma Moses gathered at her Eagle Bridge home for a funeral service. Afterward, as her neighbors watched from their porches, a hearse carried her coffin to the Maple Grove Cemetery in Hoosick Falls. There, on a cold but brilliantly sunlit day, Grandma Moses was buried next to her

Moses shares a laugh with her great-grandchildren. Her paintings often included youngsters playing in what one critic called "the everlasting morning of life."

husband, Thomas. "It was exactly what she would have wanted," said the Episcopal priest who conducted the services, "a simple, farmhouse, family funeral."

A December 23 article in *The New Yorker* magazine, one of hundreds of publications that eulogized Moses, said:

> We cannot think of the life, now concluded, of Anna Mary Robertson Moses without cheerfulness. To live one allotted span as a farm wife and mother of 10 children, and then, at the age of 76, to begin another, as an artist, as Grandma Moses, and to extend this second life into 25 years of unembarrassed productiveness—such a triumph over the normal course of things offers

small cause for mourning. If we do mourn, it is for ourselves; she had become by her 100th year one of those old people who . . . make the world seem safer.

During the decades since Grandma Moses' death, critics and art scholars have debated her lasting importance as an artist. Some have agreed with *New York Times* art critic John Canaday, who argued that "her reputation was out of all proportion to her achievement." Some have contended that hers was not "high art" because it failed to reflect the 20th century's prevailing mood of disillusionment and gloom. Others insist that, because popular taste leans toward the superficial and the sentimental, and because Moses

Family and friends attend graveside rites for Grandma Moses. Her death at the age of 101 brought expressions of sorrow and respect from all over the world.

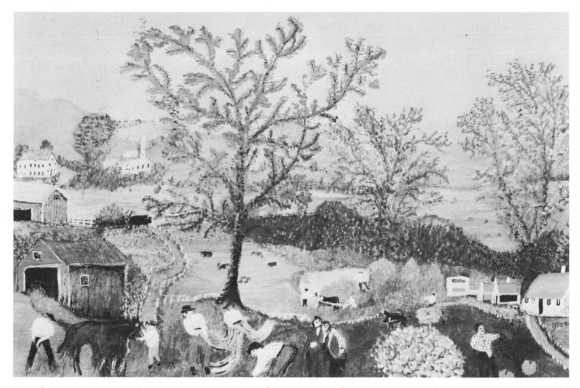

Rainbow, *completed in 1961, was Grandma Moses' last painting. The radiant work, said one critic, demonstrated Moses' conviction "that there* is *a meaning to life."*

was immensely popular, her work cannot have great value.

On the other side of the case, however, are vast numbers of people—intellectuals, art experts, and ordinary, everyday citizens—who not only find immense pleasure in Moses' paintings, but who regard her as one of the century's greatest artists. When she appeared on the art scene in the early 1940s, prominent critic Emily Genauer dismissed her appeal as the product of "very shrewd publicity." But after watching Moses' progress for 20 years, Genauer changed her mind. "Grandma became world famous," she wrote in 1961, "because her paintings were an affirmation of life in a time when the world was desperately seeking affirmation." Then (using the word *man* as shorthand for *humanity*), she said that Moses' paintings "are witness that man, if he believes in something beyond himself, if he works tirelessly, if he learns with experience, can overcome great odds."

None of these arguments would have impressed Anna Mary Moses. As art historian Jane Kallir says, "What she was up to had nothing to do with theories or fashion, and everything to do with art."

FURTHER READING

A. C. A. Galleries. *Four American Primitives: Edward Hicks, John Kane, Anna Mary Robertson Moses, Horace Pippin*. New York: A. C. A. Galleries, 1972.

Armstrong, William. *Barefoot in the Grass: The Story of Grandma Moses*. New York: Doubleday, 1971.

Kallir, Jane. *Grandma Moses, The Artist Behind the Myth*. New York: C. N. Potter: Distributed by Crown in association with Galerie St. Etienne, 1982.

Kallir, Otto. *Grandma Moses*. New York: Harry N. Abrams, Inc., 1973.

Moses, Anna Mary Robertson. *Grandma Moses. 1860–1961: May 23–June 27, 1980: Presented in association with Galerie St. Etienne*. New York: Hammer Galleries, 1980.

———. *Grandma Moses: American Primitive*. Edited by Otto Kallir. New York: Dryden Press, 1946.

———. *The Grandma Moses Storybook*. Edited by Nora Kramer. New York: Random House, 1961.

———. *My Life's History*. Edited by Otto Kallir. New York: Harper & Row, 1952.

Munro, Eleanor. *Originals: American Women Artists*. New York: Simon & Schuster, 1979.

Oneal, Zibby. *Grandma Moses: Painter of Rural America*. New York: Viking Kestrel, 1986.

CHRONOLOGY

September 7, 1860	Born Anna Mary Robertson in Washington County, New York
1872–87	Works as a domestic
1887	Marries Thomas Salmon Moses; moves to Virginia
1888	Gives birth to first of 10 children, 5 of whom survive infancy
1905	Moves to a farm in Eagle Bridge, New York, with husband and children
1918	Completes first large painting; also creates many embroidered pictures
1920	Votes for the first time
1927	Becomes a widow when Thomas Moses dies on January 15
1932–35	Keeps house for her grandchildren after death of her daughter, Anna; begins to paint rather than embroider pictures
1938	Sells a group of paintings to art collector Louis J. Caldor
1940	Visits New York City after a selection of her paintings is exhibited at Galerie St. Etienne
1941	Wins the New York State Prize for her painting *The Old Oaken Bucket*; becomes increasingly popular with American art lovers
1946	Allows her paintings to be reproduced on Christmas cards; millions are sold, increasing her fame
1949	Receives Achievement Award from Woman's National Press Club; prize is conferred by President Harry S. Truman in Washington, D.C.
1952	Publishes autobiography, *My Life History*
1955	Interviewed by journalist Edward R. Murrow on his TV show, "See It Now"
June, 1961	Paints her last picture, *Rainbow*
December 13, 1961	Dies at the age of 101

INDEX

Paintings: Grandma Moses: *Shenandoah Valley (South Branch and 1861 News of the Battle)*. Circa 1938. Oil on oilcloth, in two sections. (Kallir 51 and Kallir 52.) Grandma Moses Properties Co., New York, page 15. Grandma Moses: *Old King Church*. 1943. Oil on pressed wood. (Kallir 283.) Private collection, courtesy Galerie St. Etienne, New York, page 18. Grandma Moses: *Lincoln*. 1957. Oil on pressed wood. (Kallir 1305.) Private collection, courtesy of Galerie St. Etienne, New York, page 21. Grandma Moses: *Flying Kites*. 1951. Oil on pressed wood. (Kallir 981.) Private collection, courtesy Galerie St. Etienne, New York, page 23. Grandma Moses: *Whiteside Church*. 1959. Oil on pressed wood. (Kallir 1425.) Private collection, courtesy Galerie St. Etienne, New York, page 26. Grandma Moses: *Hoosick Falls, N. Y., in Winter*. 1944. Oil on pressed wood. (Kallir 425.) The Phillips Collection, Washington, D.C., page 27. Grandma Moses: *Eagle Bridge Hotel*. 1959. Oil on pressed wood. (Kallir 1387.) Private collection, courtesy Galerie St. Etienne, New York, pages 34–5. Grandma Moses: *Country Fair*. 1950. Oil on canvas. (Kallir 921.) Private collection, courtesy Galerie St. Etienne, New York, page 41. Grandma Moses: *Apple Butter Making*. 1947. Oil on pressed wood. (Kallir 654.) Private collection, courtesy Galerie St. Etienne, New York, pages 44–5. Grandma Moses: *Fireboard*. 1918. Oil on paper. (Kallir 1.) Grandma Moses Properties Co., New York, page 48. Grandma Moses: *Mt. Nebo on the Hill*. Before 1941. Needlework. (Kallir 34W.) Private collection, courtesy Galerie St. Etienne, New York, page 54. The Tip-up Table. Standards painted by Grandma Moses, ca. 1920. (Kallir 2.) Bennington Museum, Bennington, Vermont, page 57. Grandma Moses: *Taking in Laundry*. 1951. Oil on pressed wood. (Kallir 967.) Private collection, courtesy Galerie St. Etienne, New York, page 58. Grandma Moses: *Sugaring Off*. Before 1941. Oil on pressed wood. (Kallir 42.) Private collection, courtesy Galerie St. Etienne, New York, page 63. Grandma Moses: *On the Road to Greenwich*. Before 1941. Oil on cardboard. (Kallir 26.) Private collection, courtesy Galerie St. Etienne, New York, page 65. Grandma Moses: *The Guardian Angel*. Before 1941. Oil on pressed wood. (Kallir 29.) Grandma Moses Properties Co., New York, page 66. Grandma Moses: *The Childhood Home of Anna Mary Robertson Moses*. (Kallir 160.) Private collection, courtesy Galerie St. Etienne, New York, page 67. Grandma Moses: *The Old Automobile*. 1944. Oil on pressed wood. (Kallir 442.) Private collection, courtesy Galerie St. Etienne, New York, page 68. Grandma Moses: *Christmas at Home*. 1946. Oil on pressed wood. (Kallir 611.) Private collection,

courtesy Galerie St. Etienne, New York, page 69. Grandma Moses: *Hoosick Valley (from the Window)*. 1946. Oil on pressed wood. (Kallir 611.) Private collection, courtesy Galerie St. Etienne, New York, page 70. Grandma Moses: *A Beautiful World*. 1948. Oil on pressed wood. (Kallir 787.) Private collection, courtesy Galerie St. Etienne, New York, page 71. Grandma Moses: *Sugaring Off*. 1955. Oil on pressed wood. (Kallir 1166.) Private collection, courtesy Galerie St. Etienne, New York, page 72. Grandma Moses: *The First Automobile*. Before 1941. Oil on pressed wood. (Kallir 6.) Private collection, courtesy Galerie St. Etienne, New York, page 75. Grandma Moses: *Old Oaken Bucket*. 1941. Oil on pressed wood. (Kallir 94.) Private collection, courtesy Galerie St. Etienne, New York, page 76 (top). Grandma Moses: *Black Horses*. 1942. Oil on pressed wood. (Kallir 181.) Private collection, courtesy Galerie St. Etienne, New York, page 78. Grandma Moses: *Catching the Turkey*. 1955. Oil on pressed wood. (Kallir 1180.) Private collection, courtesy Galerie St. Etienne, New York, page 79. Pollock, Jackson: Untitled. Pollock/Krasner Foundation/ARS N.Y., 1989, Art Resource, page 89. Grandma Moses: *A House*. 1951–52. Ceramic tile. (Kallir Title No. 2.) Grandma Moses Properties Co., New York, page 91. Grandma Moses: *The Eisenhower Farm*. 1956. Oil on pressed wood. (Kallir 1205.) Private collection, courtesy Galerie St. Etienne, New York, page 94. Grandma Moses: *Waiting for Santa Claus*. 1960. Oil on pressed wood. (Kallir 1463.) Grandma Moses Properties Co., New York, page 99. Grandma Moses: *Rainbow*. 1961. Oil on pressed wood. (Kallir 1511.) Private collection, courtesy Galerie St. Etienne, New York, page 103. Photographs: courtesy Galerie St. Etienne, pages 2, 12, 19, 20, 24, 30, 31, 32, 42, 43, 46, 50, 53, 60, 62, 74, 77 (bottom), 80, 82, 83, 85, 86, 87, 88, 90, 93, 96, 98, 101, 102. Photo courtesy of Edith Beaumont/Hoosick Falls Historical Society, pages 14, 55; The Bettmann Archive, pages 40, 47; Courtesy of the Chapman Historical Museum of Glens Falls, Queensbury Historical Association, Inc., pages 16–17, 52; Courtesy of the New York State Historical Association, Cooperstown, pages 28–29; Courtesy of the Virginia State Library and Archive, pages 37, 38–39.

Tom Biracree is the author of 34 books. A former high school coach and sportswriter, he lives with his wife, Nancy, and son, Ryan, in Ridgefield, Connecticut.

❖ ❖ ❖

Matina S. Horner is president of Radcliffe College and associate professor of psychology and social relations at Harvard University. She is best known for her studies of women's motivation, achievement, and personality development. Dr. Horner serves on several national boards and advisory councils, including those of the National Science Foundation, Time Inc., and the Women's Research and Education Institute. She earned her B.A. from Bryn Mawr College and Ph.D. from the University of Michigan, and holds honorary degrees from many colleges and universities, including Mount Holyoke, Smith, Tufts, and the University of Pennsylvania.